IMAGES
of America

DUNSMUIR

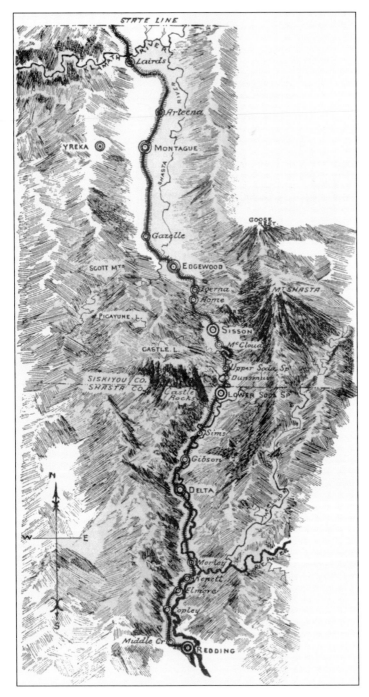

This map by E. McD. Johnstone was published in 1887 as the railroad through the Sacramento River Canyon and over the Siskiyou Mountains, in one of the most complex and expensive engineering feats of its time, neared completion. Johnstone wrote, "From Redding . . . to the base of Mount Shasta, the distance is about 80 miles, and for beauty and variety of scenery, for grandeur and sublimity, it will challenge any other 80 consecutive miles of railroading in the United States." Travel time between Redding and Dunsmuir was nearly four hours by rail. The railroad paralleled the Siskiyou Trail used for thousands of years by indigenous peoples, trappers, settlers, and entrepreneurs. Later Highway 99 and Interstate 5 followed a similar route. (College of the Siskiyous Library.)

ON THE COVER: Children are posed in front of the famed Dunsmuir fountain to celebrate Easter around 1910. It is unfortunate that so many stories like this one are lost. The authors hope that this book will be utilized in renewing efforts to preserve the rich Dunsmuir folklore for future generation's enjoyment. (Alan Moder.)

IMAGES
of America

DUNSMUIR

Deborah Harton and Ron McCloud

ARCADIA
PUBLISHING

Published by Arcadia Publishing
Charleston, South Carolina

Printed in the United States of America

Library of Congress Control Number: 2009940064

For all general information contact Arcadia Publishing at:
Telephone 843-853-2070
Fax 843-853-0044
E-mail sales@arcadiapublishing.com
For customer service and orders:
Toll-Free 1-888-313-2665

Visit us on the Internet at www.arcadiapublishing.com

This book is dedicated to all of those who, like Reva Coon and Dorothy Luttrell, reflect the spirit of this grand place. And to all those whose stories, regrettably, have been lost.

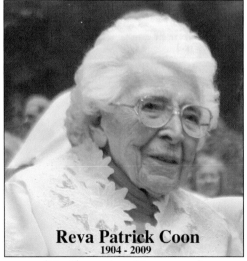

Reva Patrick Coon
1904 - 2009

(Mt. Shasta Area Newspapers.)

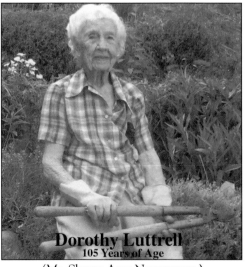

Dorothy Luttrell
105 Years of Age

(Mt. Shasta Area Newspapers.)

CONTENTS

PREFACE

Dunsmuir. The name has a Scottish ring. Why would a Northern California mountain railroad town have a Scottish name? There is a story about that. And there are other stories of triumphs and tragedies, explorers and entrepreneurs, railroad workers and storekeepers, and elegant resorts and humble auto camps. Many of the stories consist of the written word or oral tradition, and there are photographs of some. Unfortunately stories get forgotten, and photographs fade or are lost. The authors' goal in this book is to preserve some of both.

The legend of how a wealthy Canadian coal baron named Alexander Dunsmuir visited the area, fell in love with it, and promised the gift of a fountain if it could be named for his family has been told and retold. However, the record is not entirely clear. Both Alexander Dunsmuir and his father, Robert, had reason to be interested in the completion of the railroad connecting California with Oregon. Their thriving coal business in Vancouver could benefit from rail transportation to San Francisco, and Alexander had homes in both Vancouver and San Francisco. Both Alexander and Robert were in the area between 1886 and 1888.

In August 1886, the railroad reached a place called Cedar Flat, later called Nutglade, in the area of the present railroad south yard. The station at that time consisted of a boxcar, which served as a railroad headquarters and telegraph office and, according to contemporary reports, was called Dunsmuir. In January 1887, this Dunsmuir station was moved north to an area called Pusher (the current railroad yard) where an engine house and turntable were being built. In June 1888, according to the *Mott North Star* newspaper, "Honorable R. Dunsmuir" was in Dunsmuir and "intimated" that he would give a fountain to the town, which was already called Dunsmuir. In October 1888, the fountain was delivered with $360 to cover installation costs, provided by "Honorable Mr. Dunsmuir." The plaque on the fountain clearly says it was given by Alexander Dunsmuir.

It may never be known which of the Dunsmuirs—father or son—promised and gave the fountain to the settlement which already bore their name.

Other Dunsmuir stories also need to be told. Stories about the building of the railroad that give birth to the town, the elegant, world-class resorts that are now gone, the German cannon on Dunsmuir Avenue, the landslide that swept across the town, the fire that nearly destroyed the town in its infancy, the world famous Dunsmuir fly fisherman, and the street named for the pretty daughter of a founding father.

There are echoes of the past in Dunsmuir's historic buildings, in the streets and parks, and even in the river and the surrounding landforms. As the authors collected photographs for this book, delved deeply into historical records, read every available resource, and listened to the stories of folks who were there back in the day, they grew to appreciate this town of Dunsmuir and all that has gone on over the years to make it what it is today. They hope that you will find the following images from the past to be as fascinating as they have.

ACKNOWLEDGMENTS

The creation of this book was an amazing community project, with many individuals offering images, stories, advice, support, enthusiasm, and proofreading services. Special thanks to Alan Moder and Claudia East who unwittingly instigated this project through their generosity and mentorship, as well as to our gracious guest author Angel Gomez (and Valerie Masson-Gomez), whose expertise on the Siskiyou Trail and Upper Soda Springs was invaluable. Dennis Freeman, Marcia Eblen and staff of College of the Siskiyous Library, Michael Hendryx, Dick Terwilliger, and Judy Carlock-Powell of the Siskiyou County Museum also deserve special accolades for their support and enthusiasm. We are grateful to Jerry Harmon, Dave Maffei, Bruce Petty, Ralph Menges, and Evonne Moffett (Branstetter/Silva family archivists), John Signor, and Bob Morris for their incredible knowledge and willingness to share. The following folks also generously provided assistance: Adrianne Arata, Paul Carter, Deborah Cismowski (California Department of Transportation), Larry Cook, Janet Crittendon, Bruce Davies (Craigdarroch Castle Historical Museum), the Duncan family, the Dunsmuir and Cedar Flat Model Railroad Club, the Dunsmuir Chamber of Commerce, Linda Freeman, Rich Gabrielson (the car guy), Steve Gerace (Mt. Shasta Area Newspapers), Kaye Hall (daughter of Ivan Tucker of Martin and Tucker Photographic Studios), Sabrina Heise (editor, Arcadia Publishing), Bill Hirt, Donna Howell, David Mandel (production coordinator, Arcadia Publishing), the Manfredi family, Darla Mazariegos, Jan Mitchell (Pacific Power and Light), Linda Price, the Shasta Division Archives, the Siskiyou County Historical Society, Bernita Tickner, Devon Weston (publisher, Arcadia Publishing), and John Wynant.

Deb would like to thank Siskiyou County employees, the fabulous Ferguson family of Weed (April, Renae, Stephanie Robin, RaeAnne, Nolan, Sonia, Taylor, and Phil), Joyce Goodwin, as well as her family. "I would not have survived the last three years without you. In your compassion and passion, the generous and gracious spirit of Dunsmuir and all of Siskiyou County is reflected." This spirit is also reflected in my partner extraordinaire, Ron McCloud. Thank you for making this book happen. And to the beautiful Riley-Roo who makes the light in my heart sparkly.

Ron would like to thank Deb Harton, for inviting me to accompany her on this journey. It's been one of the most fascinating, exciting, rewarding, and just plain fun experiences of my life. Thanks to my wife, Pat, for her proofreading and suggestions, and for putting up with my stacks of papers, my late night computer work, and my general state of distraction. And thanks so much to all of the many wonderful folks who almost daily asked, "How's the book going?" and offering their encouragement. What a great place this is!

INTRODUCTION

For thousands of years, the Dunsmuir area was a natural place for travelers to stay on journeys between California and Oregon. Some 10,000 years ago, the earliest people in this area created a trail from the Pacific Northwest to San Francisco Bay; this trail was later known as the Siskiyou Trail—an ancient route that passes through today's Dunsmuir.

Just before the arrival of Europeans and Americans, the people who lived south of Mount Shasta where Dunsmuir is today were the Okwanuchu. No one knows what happened to the Okwanuchu. Neighboring tribes, such as the Wintu and Shasta, began to live in some of the areas that were once Okwanuchu territory.

The first non-Native Americans to venture along the Siskiyou Trail were trappers of the Hudson's Bay Company in the 1820s. They came from today's Washington state, seeking furs and pelts. Alexander McLeod, a trapper, reached the Sacramento River in 1828. He was followed by others including Peter Skene Ogden and Michael LaFramboise. In a remarkable effort in 1834, Ewing Young drove a herd of horses and mules through the Sacramento River canyon on the way from the missions in California to settlements in Oregon. He repeated the drive in 1837 with 700 cattle.

The U.S. Exploring Expedition passed through in 1841. They traveled south from Portland to San Francisco, formally documenting the natural history of the area. They were the first to assign the name "Shaste" to the mountain that came to be known as Shasta.

The first large numbers of Americans came with the Gold Rush beginning in 1848. Prospectors by the thousands traveled along the Siskiyou Trail in search of riches. The first American settlement, in what became Dunsmuir, was built at Upper Soda Springs by the Lockhart brothers in 1852. They raised a log cabin for people traveling along the Siskiyou Trail. This was likely the first structure built within the city limits of today's Dunsmuir.

In 1855, pioneers Ross and Mary McCloud bought the property at Upper Soda Springs, plus most of what would become today's North Dunsmuir. The McClouds built a toll bridge over the Sacramento, expanded the inn, and built a springhouse for the delicious soda water that bubbled up nearby.

In the 1850s, members of a Wintu Indian family from the nearby Trinity River fled attacks by prospectors and hostile tribes. They came to Upper Soda Springs and were given safe refuge there. This family, the Tauhindaulis, lived and worked at Upper Soda Springs for many years. In 1855, a raid by Native Americans on food stored near Castle Crags by pioneer Joe DeBlondy led to the Battle of Castle Crags. The poet Joaquin Miller was wounded in this fight and later wrote about his experience.

In the 1860s, a stagecoach road was completed. Ten years later, an elegant two-story hotel was built at Upper Soda Springs.

The arrival of the railroad in 1886 brought more people to what was known as Upper Soda Springs Resort. In the fashion of the Victorian era, people would come and stay a month, taking in the waters and enjoying the healthful air and scenery.

Sadly, by the 1920s the resort faded and went out of business, leaving only memories and photographs. By then, however, the vibrant new town of Dunsmuir had grown up surrounding the site of the hotel. Today a new park along the Sacramento River helps keep alive the memory of the first Gold Rush–era settlement within what would become Dunsmuir.

—Angel Gomez

One

THE EARLY DAYS

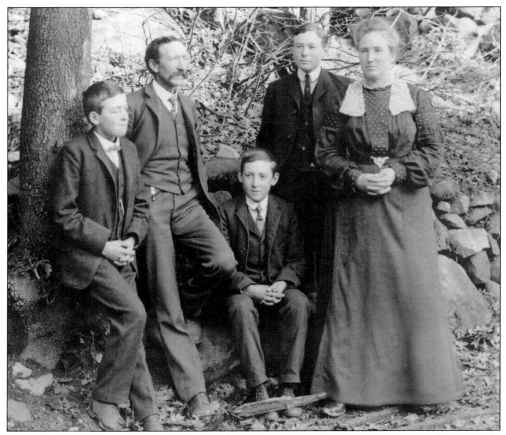

Elda McCloud Masson and her husband, John Masson, second-generation owners of Upper Soda Springs Resort, are pictured with their children around 1900. John Masson stayed at Upper Soda Springs while working as an accountant for Central Pacific during the construction of the railroad in 1886. The guest writer of this book, Angel Gomez, is the great grandson of John and Elda. (© Masson-Gomez family.)

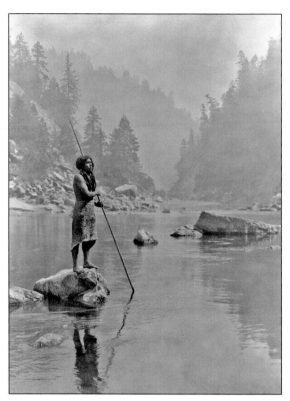

The first humans in the area around Dunsmuir likely came 10,000 years ago—bands of hunters following elk and woolly mammoths. The earliest human settlements around Dunsmuir were about 7,000 years ago. The earliest inhabitants will probably never be known—they are called simply Paleo-Indians, and they have left no known descendants. This picture from the nearby Hupa reservation illustrates what life may have been like for these earliest inhabitants. (Edward S. Curtis Collection, Library of Congress.)

Over thousands of years, several groups of people lived in the area around Dunsmuir, and then died out or were pushed out by a new group. By the 1820s, the people living around what would become Dunsmuir were the Okwanuchu tribe. There were perhaps a thousand Okwanuchu; however, today not a single Okwanuchu remains. They remain Dunsmuir's mystery tribe. (Siskiyou County Museum.)

In the 1820s, the first Europeans or Americans to pass through the site of today's Dunsmuir were hunters and trappers from the famous Hudson's Bay Company. These trapping groups came down from today's Washington State into Mexican-controlled California along a network of footpaths, which became known as the Siskiyou Trail. Pictured here are Michael LaFramboise and his family. LaFramboise was the leader of one of the first Hudson's Bay expeditions to come through what is now Dunsmuir. (Douglas County Museum.)

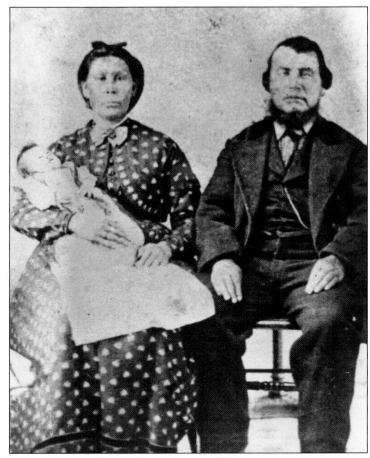

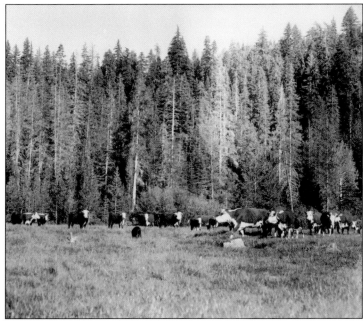

In the 1830s, the new American settlements in the Oregon territory needed horses and cattle. Pioneer Ewing Young made the daring decision to come through the wilderness along the Siskiyou Trail, buy herds of cattle in California, and drive them back over 500 miles to Oregon. These monumental cattle drives lasted more than three months and came through the site of today's Dunsmuir. (Siskiyou County Museum.)

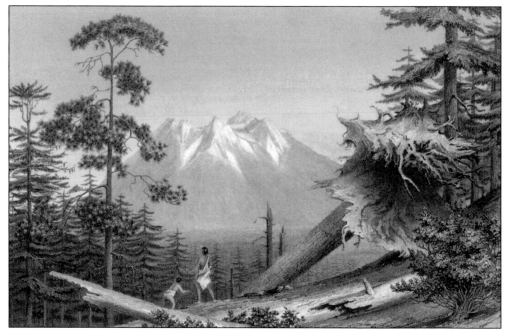

Congress sent the U.S. Exploring Expedition on a trip of scientific exploration around the world. In the early 1840s, the expedition visited Oregon and California. A group of scientists and mapmakers came down the Siskiyou Trail from Portland to San Francisco. One of the artists, Alfred T. Agate, created this earliest-known image of Mount Shasta. (College of the Sisikyous Library.)

The California Gold Rush brought large numbers of Forty-Niners along the Siskiyou Trail and through today's Dunsmuir. In 1852, the Lockhart brothers built a log cabin for travelers at Upper Soda Springs, and in 1855, pioneers Ross and Mary McCloud bought the property and added a two-story inn and a toll bridge across the Sacramento. Ross and Mary (with their children and partner, Isaac Fry) can be seen standing in front of the two-story inn. (Siskiyou County Museum.)

In 1855, Native Americans raiding settler camps took food from Joe DeBlondy near Lower Soda Springs, which led to the Battle of Castle Crags. A retaliatory attack by settlers and Native American allies took place near Battle Rock, above Castle Lake. The poet Joaquin Miller (pictured here as an adult) was 16 years old at the time and was wounded in the cheek and neck by an arrow. He was nursed back to health at Portuguese Flat by Mary McCloud. (College of the Siskiyous Library.)

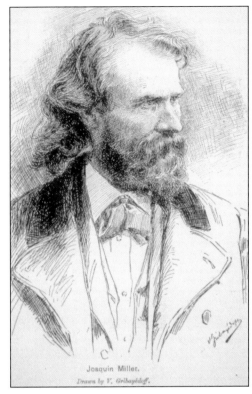

Joaquin Miller.
Drawn by V. Gribayédoff.

In the 1850s, members of a Wintu Indian family from the nearby Trinity River fled attacks by prospectors and hostile tribes. They came to Upper Soda Springs and found refuge there. Grant Towendolly (as he preferred the spelling of his name), pictured here as a young man, later contributed Trinity Wintu legends and religious stories for a book called *A Bag of Bones*. (College of the Siskiyous Library.)

13

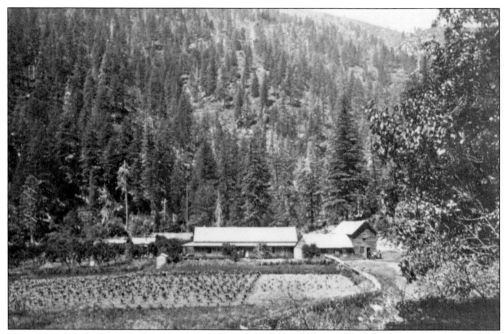

A stagecoach road built by Ross McCloud led from today's Mount Shasta City to Upper Soda Springs, and by the early 1860s, a new stagecoach road was finally completed up the Sacramento Canyon to Upper Soda Springs. New buildings were added to what became known as Upper Soda Springs Hotel, and tourists came from the Bay Area (and around the world) to enjoy the scenery, hunting, fishing, and of course, the nearby soda water. (Siskiyou County Museum.)

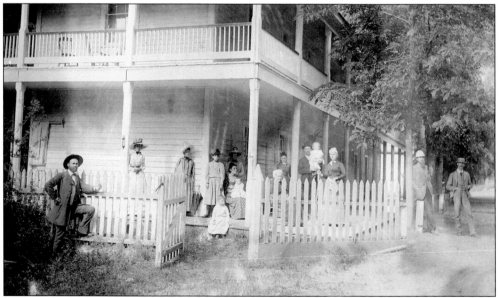

In the early 1870s, the McClouds' business partner, Isaac Fry (pictured here at left), built this two-story building at Upper Soda Springs. During this time, young Elda McCloud (daughter of pioneers Ross and Mary McCloud) suggested to a group of visiting scientists that a local fish should be called the Dolly Varden trout. That name is now applied to similar fish species around the Pacific. (Siskiyou County Museum.)

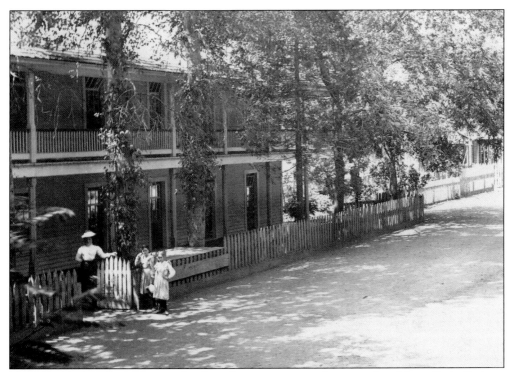

Following the fashion of the era, families often came to stay for a month at Upper Soda Springs, to "take in the waters." Remarkably, the trees shown in this photograph are still there today, across the street from the soda water springs. (© Masson-Gomez family.)

This image shows Upper Soda Springs as it appeared in the last days of stagecoach travel. A description written at the time boasted that at Upper Soda Springs, "The table groans with plenty. There is yellow butter and creamy cheese . . . blocks of white honey in the comb, potatoes that laugh their skins off, young venison, and trout, quail, and hare in their seasons and fruit dishes full of great, fat, red-cheeked apples. The healing qualities of the soda, iron, and magnesia waters hereabouts are wonderfully efficacious in the cure of all maladies save two—love and lying." (College of the Siskiyous Library.)

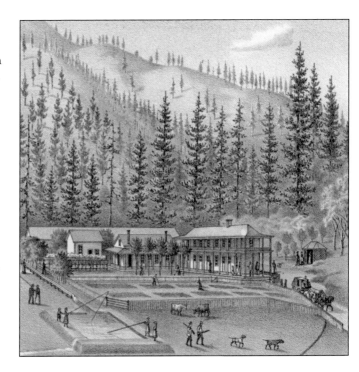

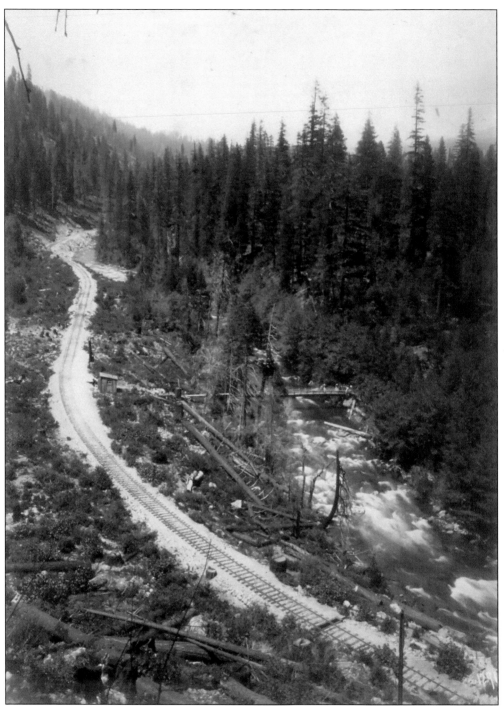

In 1886, the newly constructed railroad (evidenced by the clean ballast and fresh-cut stump) brought dramatic changes. A new town, Dunsmuir was being built just a half-mile down the Sacramento from Upper Soda Springs. A footbridge (pictured here) was built across the Sacramento from a railroad stop to what was now named the Upper Soda Springs Resort. (The Bancroft Library, University of California, Berkeley.)

The snowshed above Upper Soda Springs was constructed in response to the severe storms of 1890 following an avalanche in the area. In 1895, a series of avalanches from the slopes of Mount Bradley covered the tracks with debris 60 feet deep. The snowshed was abandoned in 1915. (© Dave Maffei.)

In this image, Marcelle Sayler Masson waits for the train at the Upper Soda Springs station. Unfortunately, not long after her marriage to Charles Masson (son of John and Elda Masson) in 1919, Upper Soda Springs Resort closed for good, the result of changing fashions and tastes in vacations. (© Masson-Gomez family.)

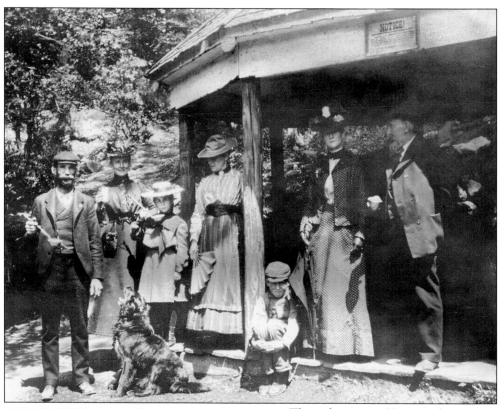

The soda water at Upper Soda Springs was lightly carbonated, with a pleasant taste. The soda water could be enjoyed taken directly from the springs (pictured here), or mixed as lemonade and enjoyed while relaxing on the lawns at the resort. Soda water was bottled at Upper Soda Springs Resort. The bottle on the left sits on the cistern that remains on the site of the original spring house shown above. Today a park honoring all these events and history occupies the site of the original Upper Soda Springs Resort. (Above, © Masson-Gomez family; left, Deb Harton.)

Two

MINING AND LOGGING

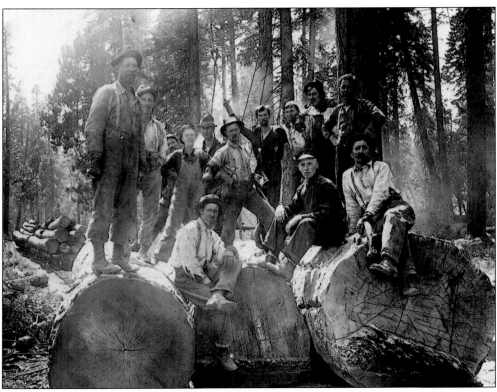

Early mills supplied wood for building as the canyon was settled. Those in operation by 1886 prospered as the railroad purchased wood for ties, trestles, and fuel. As demand increased, more mills began operations, and over time, more than 50 were established nearby. The railroad made logging and milling more efficient, as timber could be milled and shipped anywhere. Logging camps could be located as far out as a company was willing to build a spur, and remains of mills, camps, and spurs crisscross the region. Dunsmuir, surrounded by thick forests, seemed destined to be a logging town. The industry slowed as the railroad neared completion, when Southern Pacific began using alternative fuels, and during the Great Depression, but was stimulated during World War II. The fickle industry is closely regulated by availability, accessibility, and demand. Truck logging further opened the industry, and logging took place anywhere a road could be built. Presently, only two large mills remain in operation within Siskiyou County with the majority of timber being cut on large private timber holdings. The lure of riches also brought many miners to the area. Rich strikes were located to the north, south, and west, but close to Dunsmuir there was more speculation than mining. (Duncan family.)

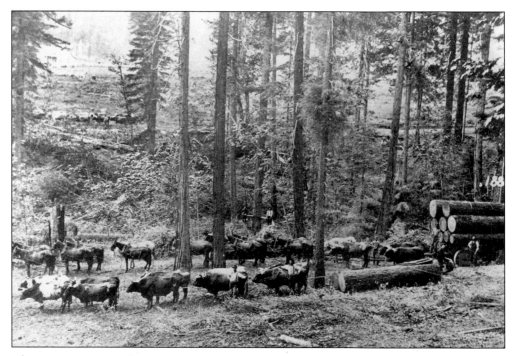

In 1886, James J. Scott, along with three partners, filed timber claims north of Dunsmuir. They built a mill capable of turning out 25,000 board feet of lumber per day. Many homes and businesses in Dunsmuir were constructed from lumber milled at this location, which was later moved slightly south to Hedge Creek. The mill was sold to Leland, Wood, and Sheldon in 1896 and was dismantled. Though used mostly on flat terrain, animals were the primary means of moving logs. Most mills were small, easily dismantled, and moved when the timber in a given area was exhausted. (Above, Ralph Menges and Evonne Moffett; below, College of the Siskiyous Library.)

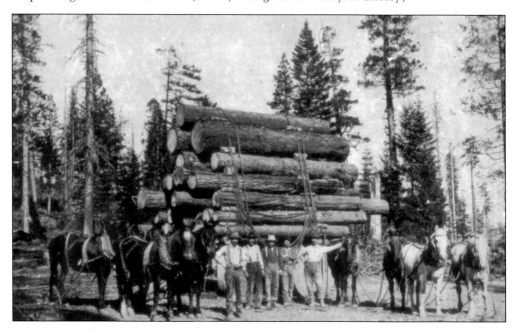

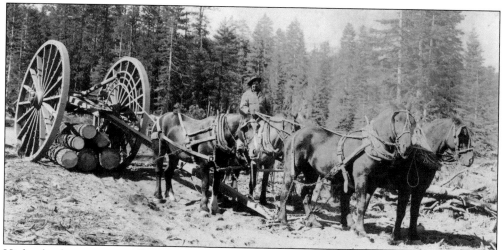

High wheels were most efficient when used on flat, dry ground, which ruled out much of the area surrounding Dunsmuir. Using high wheels, logs could be skidded more easily to a landing with the front end raised off the ground. Teams of horses continued to be used to load wagons or flat cars until the advent of steam. Timber fallers fell the trees, then limbers or "knot bumpers" cleared brush and limbs. Buckers then cut the logs into predetermined lengths, and "swampers" cut roads for the livestock to skid the logs down. In 1904, the average salary was between $2.25 and $2.75 per day. (Siskiyou County Museum.)

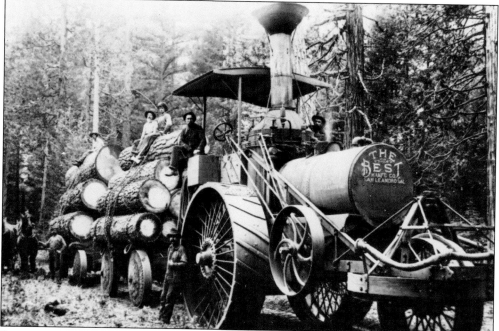

Steam equipment soon replaced livestock. Approximately 100,000 board feet of logs could be hauled per day using steam-operated equipment such as the Best tractor shown above. In 1881, John Dolbeer developed the first practical mechanical logging engine, commonly called a steam donkey. It could skid logs on slopes over 15 degrees and operated at about half the cost of livestock, and did not have to be fed in the winter. How the bosses in the canyon must have rejoiced! (Dunsmuir Chamber of Commerce.)

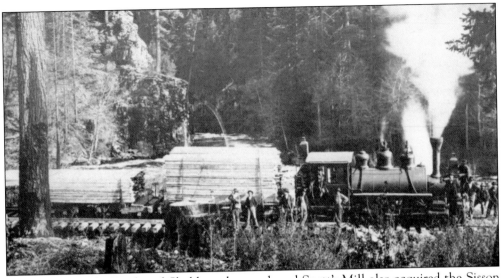

The same Leland, Wood, and Sheldon who purchased Scott's Mill also acquired the Sisson Lumber Company in 1896. When Leland sold his interest to the other partners in 1901, Wood and Sheldon relocated the mill to a site above the head of Box Canyon, shown here about where the Lake Siskiyou dam is located today. Later moved and renamed Rainbow Mill, over 15 miles of standard gauge rail was built and utilized over the next 20 years. This 1884 Baldwin engine ran off the rails so often, it was nicknamed GOP for "get out and push." GOP was taken out of service by 1936 and is now displayed at the Collier Memorial State Park Logging Museum in Southern Oregon. (College of the Siskiyous Library.)

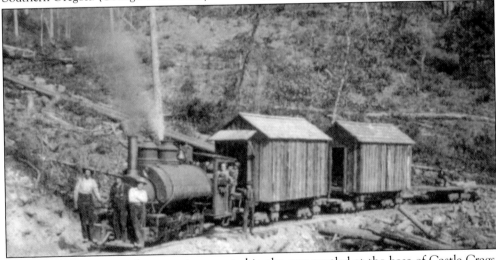

At different times, several companies operated in the area nestled at the base of Castle Crags, including the Castle Creek Lumber Company. In 1912, the M. A. Burns Lumber Company began operations using a narrow gauge railroad. The railroad increased the mobility of lumber camps that could pack up and move at almost a moments notice when surrounding timber was used up. Workers lived in tents, railroad cars, or skid shacks. Three types of camps existed: the woods camp located near a siding, a semi-permanent mainline camp, and the headquarters, with operations, offices and repair facilities. Loggers were famous for their enormous appetites and the extra calories were essential, as the work was hard. Word traveled quickly, and the camps providing the best food usually hired on the best men. (College of the Siskiyous Library.)

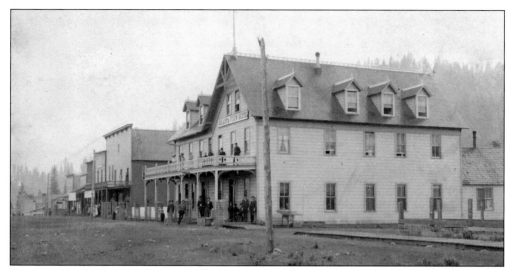

Southern Pacific created the town of Mott north of Dunsmuir in 1886. Named after the first road master in Dunsmuir, Joseph Mott, and identified as a lumber town, Mott was larger than Dunsmuir at one time. The *Mott North Star*, Mott's newspaper, began publication in 1887, while Dunsmuir's followed three years later. By then, the timber stands were mostly played out and the railroad, which required enormous amounts of timber during construction, was complete. Mott was already feeling the decline in July 1890 when the newspaper's last edition was published. In 1892, the Shasta View Hotel, pictured above, burned and was not rebuilt. All that is left of Mott today is a few bricks near the Mott exit off Interstate 5. (Western Railway Museum.)

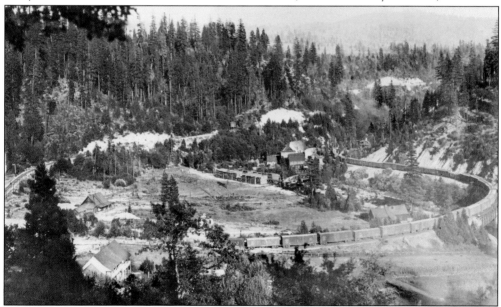

Several mills operated north of Dunsmuir at the railroad's 18th crossing of the Sacramento River. The original was built by T. H. Bardshaw in 1892. Named the Cantara Lumber Company when acquired by the Truckee Lumber Company, it was surrounded by the steep, 14-degree Cantara Loop that let the railroad climb up and out of the Sacramento River canyon. Logs were lowered from the steep surrounding hills by means of a cable tramway. It was abandoned around 1917, when the stands of timber were depleted. (Siskiyou County Museum.)

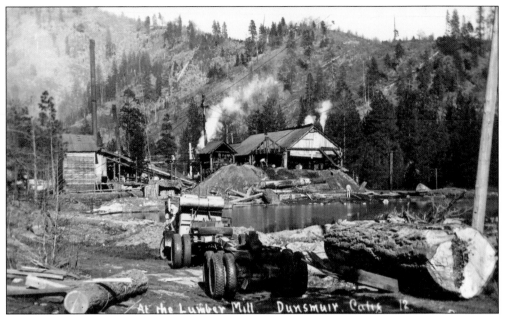

With the increased use of log trucks, large-scale railroad logging became obsolete. The Dunsmuir Lumber Company (1934), located on Crag View Drive, demonstrated an industry in transition, as it utilized steam and what seems to be an old skidder to move logs from the pond onto the deck. The timber industry around Dunsmuir has never regained the volume and momentum of those early days. This mill burned in 1953 and closed shortly thereafter. (Alan Moder.)

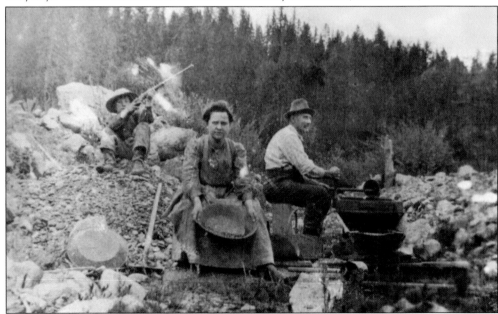

Most gold was laboriously panned south of Dunsmuir at Lower Soda Creek, Portuguese Flat, and Dog Creek. Fortunate miners made $5 per day, a good wage that hardly supported them in the highly inflated mining camp stores. There was much speculation in Dunsmuir regarding gold and silver deposits, but little in the way of yields. Deposits of chromite, mercury, and asbestos occurred closer to Dunsmuir. (Siskiyou County Museum.)

Three

THE RAILROAD

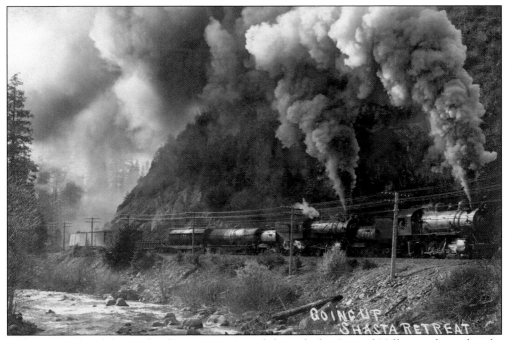

Before the railroad, heavy freight was transported through the Central Valley via ferry, then by wagon and mule. The railroad's gift to Dunsmuir was everlasting life in that it fully opened the Sacramento Canyon, easing transportation of goods, creating jobs, and increasing commerce. Before construction, people flooded the canyon anticipating the new business opportunities provided by the change in circumstances. The route was surveyed in 1863, and today's rails follow a path similar to trails used for thousands of years. Establishing and maintaining a route through the Sacramento River Canyon and the Siskiyous to the north was no minor feat. Many thought it was impossible. William Hood, chief engineer for the Southern Pacific from 1885 to 1921, described the Siskiyous as being, "of exceedingly formidable character . . . [that] will compare with the most expensive railroads ever constructed." The following images are not intended to be a complete history of the railroad. John Signor's book, *Southern Pacific's Shasta Division—Over a Century of Railroading in the Shadow of Mount Shasta*, provides a more comprehensive and precise history of the railroad. This presentation offers some highlights in which the importance of the railroad in Dunsmuir's history is clearly evident. (Alan Moder.)

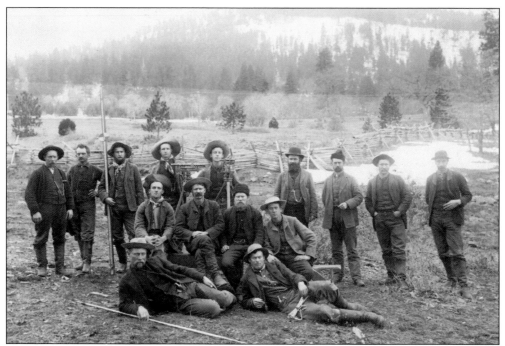

California legislators granted permission for interested parties to explore the feasibility of a railway into Oregon in 1863. Opening trade with Oregon would be a boon to California and was an old concept, though it was thought impossible via the Sacramento River Canyon. The same year, Samuel Elliot headed the survey, mapping out a route that closely followed the Siskiyou Trail. As late as May 1887, surveyors were still searching for a less complex and costly route through the Siskiyou Mountains. Construction moved north in 1869, reached Redding and stalled, then Delta and stalled again. The tracks reached Lower Soda Springs by July 1886. Nestled at the base of Castle Crags (below), this photograph may be the very camp used by construction workers at that time. Construction reached lower Dunsmuir in August. (Above, Siskiyou County Museum; below, © Masson-Gomez family.)

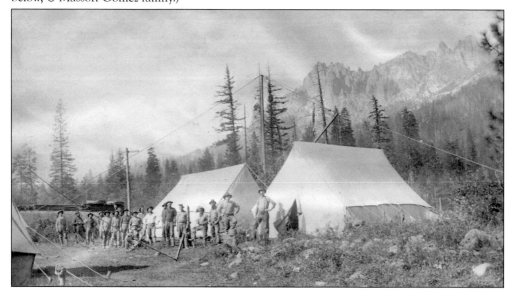

This wooden support structure was used when building the original steel truss bridge at the 16th crossing just north of Mossbrae Falls in 1886. The plate in the bridge today indicates it was built in 1901. Perhaps it was damaged in one of the many slides that occurred nearby over the next few years. The track beneath the framework carried supplies to the workers. (© Masson-Gomez family.)

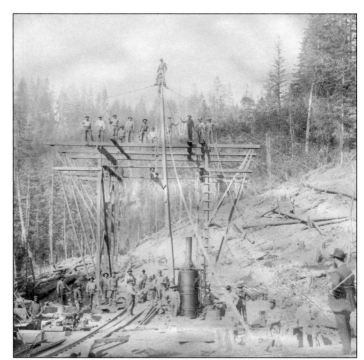

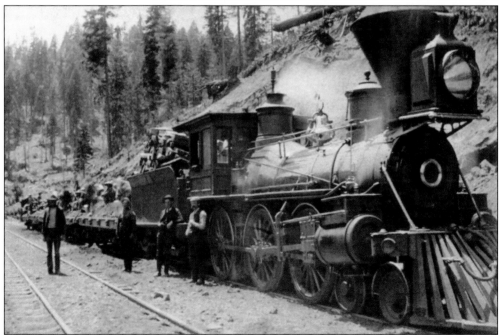

An old, wood-burning locomotive is used for transport of labor and materials. Note the Chinese individuals riding on the flatcar. The railroad employed thousands of Chinese for cheap labor. Approximately 2,000 men, mostly Chinese, worked on construction in 1886. Slavonian masonry crews were followed by the Chinese track layers. When the terminus reached McCloud Station (now Azalea) just north of the 18th crossing and out of the Sacramento River Canyon, 4,500 Chinese were employed at Dietz (Deetz) in grading the road to the north. (Paul Carter.)

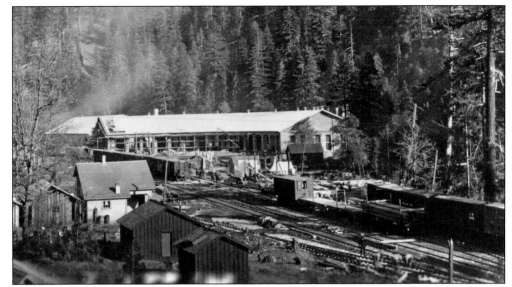

The roundhouse and other buildings seem to spring from the thick forest during construction. Dunsmuir became a railroad town by nature of its geographic location at the top of the Sacramento Canyon. The heavy grade required extra engines at this point in order to continue north up and out of the canyon. Reference to the railroad's Shasta Division first appeared in June 1887. Collis P. Huntington quickly assigned the headquarters to Dunsmuir. Construction on car shops and the roundhouse began almost immediately. With only 822 track miles, it was the smallest of divisions but well-known for its notorious curves and grades (3.3 percent over the Siskiyous). (John Signor.)

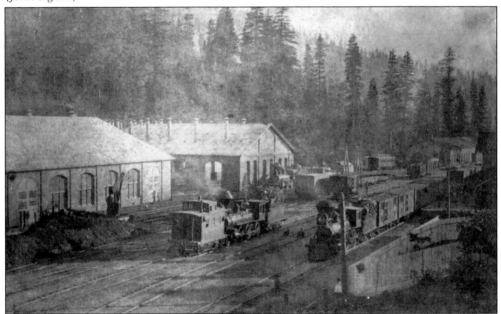

Construction slowed in the early 1890s, though the yard was still being developed. The machine shop and roundhouse seem completed. The machines in the shops were belt-driven by an overhead shaft powered by a steam boiler, possibly a locomotive, and each of the 18 stalls in the roundhouse had its own vent. (John Signor.)

This image, taken about 1910 by Earl A. McGarry, a photographer who turned his images into the stereoviews that were so popular as entertainment and educational tools, provides a closer view of the turntable. A rotary plow is located in the background to the left and the flatcar in the right foreground is clearly marked "Dunsmuir." (John Signor.)

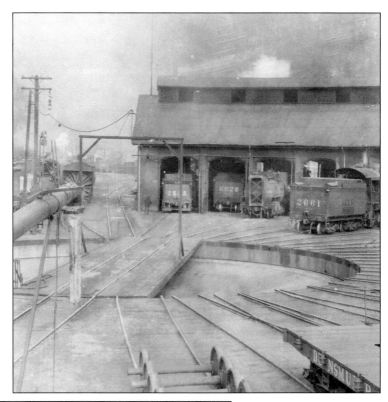

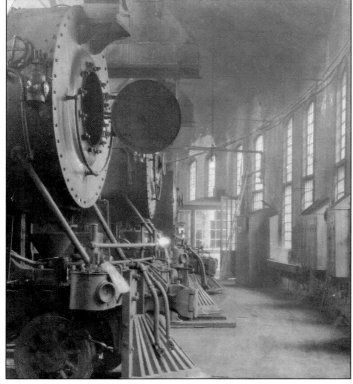

The roundhouse was used for servicing locomotives. Regardless of the type of fuel used, it was necessary to service the firebox, as it weathered direct contact with flame to heat water for steam. Employees often fished the Sacramento River flowing just below the windows. (John Signor.)

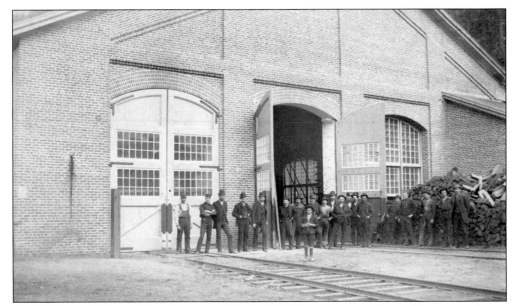

A c. 1899 view of the machine shop, one of the first buildings constructed, reveals many employees eager for work. By now, Southern Pacific was the largest employer north of Sacramento. By 1936, Dunsmuir's monthly payroll was approximately $80,000, and over 700 men were employed. Forty worked in the car shop and 120 in the offices and machine shop. (Bruce Petty.)

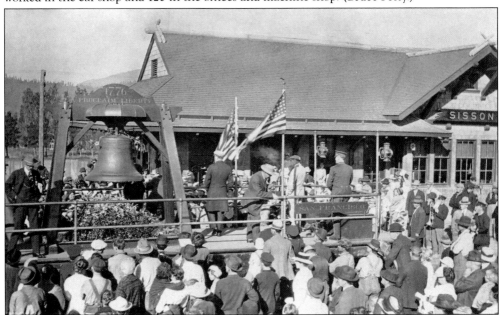

The railroad not only opened the Sacramento Canyon to miners, lumbermen, commerce, and settlers, but it also increased opportunities for their education and entertainment. On July 16, 1915, the Liberty Bell traveled through Siskiyou County on its way to the Panama Pacific International Exposition in San Francisco. The train carrying the bell stopped in both Sisson and Dunsmuir with a delegation of guards from Philadelphia and a contingent of policemen. The fire siren was activated before its arrival, and most of the town responded, including the Dunsmuir Band. The *Dunsmuir News* reported that little children kissed the bell. (Alan Moder.)

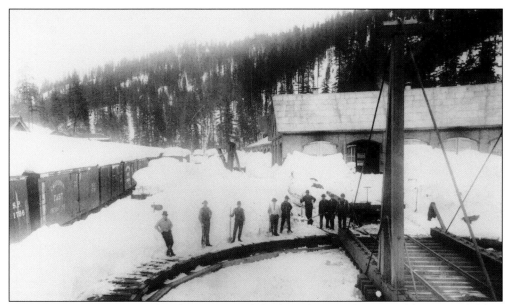

Central Pacific almost immediately encountered the fury of storms that caused damage and delays throughout the canyon. The winter of 1890 was especially harsh as 16 feet of snow accumulated at Sisson to the north. The snowfall caused the entire system to shut down for nearly 48 days, and a train, including Colonel Crocker's personal car the Mishawauka, was nearly buried at Sims. In 1936, over 15 feet of snow fell only to be repeated the next year. The Dunsmuir yard was frantically cleared by hand. More than 180 cars were manually loaded with snow to be dumped elsewhere. (John Signor.)

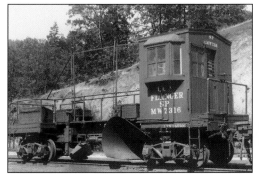

Flangers (left, c. 1950) were used as the first defense in snow removal operations, though their primary purpose was to spread ballast between the rails during construction. To the right, spreaders were utilized when snow became heavier as well as for spreading ballast outside the rails. Maintenance of Way (MOW) was responsible for keeping the route open and was the unsung hero of the entire division. (Left, photograph by Al Phelps; both courtesy John Signor.)

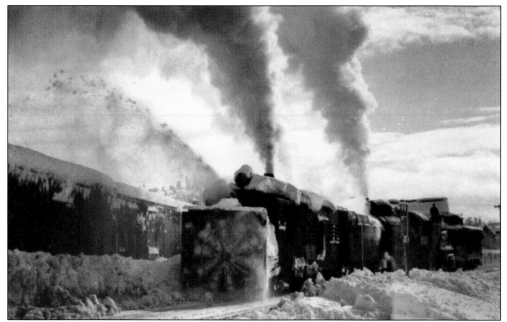

Rotary plows were first mentioned by the *Mott North Star* in 1887. They were thought to be Southern Pacific's answer to severe snowfall. Maintained by the McCloud River Railroad nearby, the wedge plow (below) was an alternate to the costly rotary. It took 14 men and two engines to force through the snow between Sisson and McCloud. A wedge plow similar to this can be viewed at nearby Railroad Park Resort. (Above, Siskiyou County Museum; below, Dunsmuir Chamber of Commerce.)

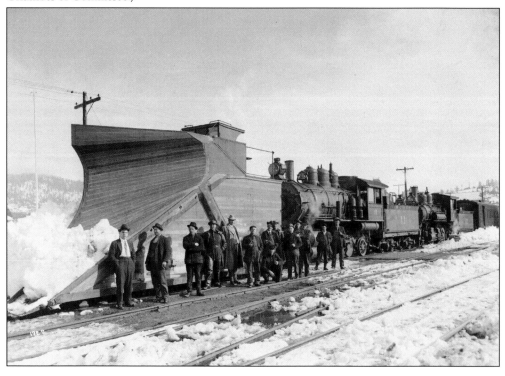

Almost from completion, the railroad heavily promoted the Siskiyou Line and advertised heavily in the San Francisco Bay Area and other heavily populated areas. *Sunset Magazine* was created as a promotional tool by Southern Pacific in 1898. This 1917 advertisement came from a prominent San Francisco paper, most likely the *San Francisco Examiner*, run by William Randolph Hearst, who owned the Wintun estate located along the McCloud River. (Deb Harton.)

The Railway Club at Dunsmuir was already in place when F. G. Athearn, director of Southern Pacific Clubs, wrote an article for *Sunset Magazine* in 1907. He told how their purpose was to increase morale and efficiency by providing positive options to employees. Rather than choosing activities of a more dubious nature, employees could pay a dime for a hot shower in clean facilities, 15¢ for a clean bed during a stopover, use the billiard room (5¢ per hour and gambling was not tolerated) or library. A large hall was provided for dances or lectures, and a secretary worked at each location, ready to provide a smile or personal assistance. (Alan Moder.)

From the Car Window

SHASTA ROUTE

Mount Lassen—Castle Crags—Sacramento River Canyon—Snow Capped Shasta—Pilot Rock—The Summits of the Siskiyous—Mount McLoughlin—Table Mountain—The Cascade Range—Cow Creek Canyon—The Valleys of the Rogue, Umpqua and Willamette Rivers—Mount Jefferson and the Three Sisters—Mount Hood—Mount Rainier and the Columbia River.

A Succession of Views Unequaled in Their Combination.

The Route for Side Trips to Crater Lake National Park, the Klamath Lake Region and the Columbia River Highway.

Three Trains Daily
San Francisco (Ferry Station) to Portland, Tacoma and Seattle
"Shasta Limited," Extra Fare $5, 11:00 A. M.
"Portland Express" 11:40 A. M.
"Oregon Express" 8:20 P. M.

UNEXCELLED DINING CAR SERVICE

For Fares and Berths, Ask Agents, or Phone Sutter 6300.

SOUTHERN PACIFIC

Write for Folder on the Apache Trail of Arizona

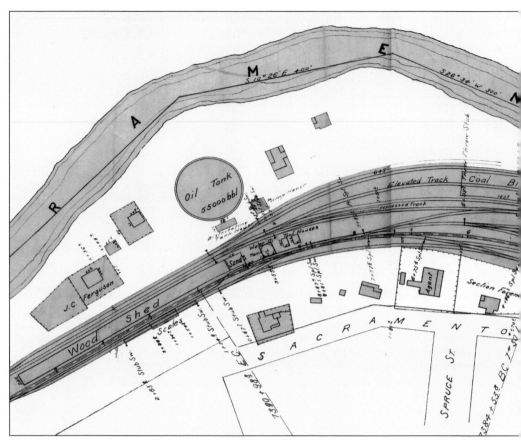

The Dunsmuir yard was a comprehensive and complex system by 1903. The woodshed shown above left fueled, sanded, and watered the trains previous to the construction of the lower yard. The roundhouse serviced locomotives and performed small repairs. The yard was continually modified for the next 50 years. Depot construction was completed early, though it, too, underwent

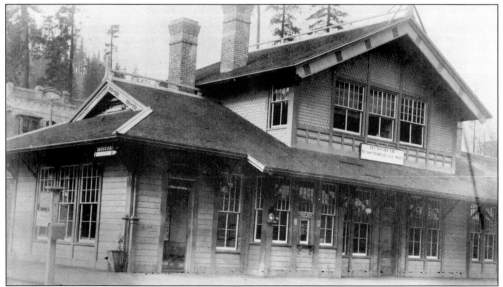

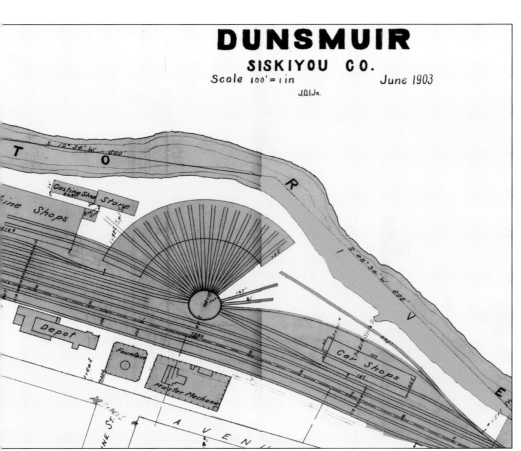

DUNSMUIR
SISKIYOU CO.
Scale 100'= 1 in June 1903

several changes. It was modified to accommodate the Shasta Division Offices and once again in the 1940s. At that time, a concrete addition that housed dispatchers and the central traffic control (CTC) was built, and still exists on the north side of the depot. (Above, Shasta Division Archives; opposite below, Siskiyou County Museum.)

More track space to make up trains and for fueling soon became necessary, prompting construction of another rail yard. This lower yard, located south of the main yard at the historic sites of Cedar Flat and Nutglade, was originally laid out in 1916. There were 17 tracks on a 1-percent grade. It was closed in 1968, mostly due to the technology that produced more powerful locomotives with larger fuel tanks and the CTC. From left to right are Interstate 5, Highway 99, the lower yard, and the Sacramento River. (Dunsmuir Chamber of Commerce.)

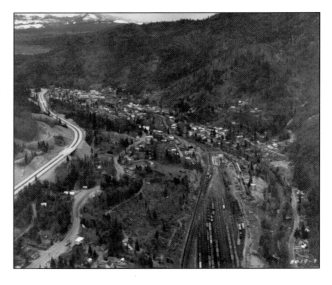

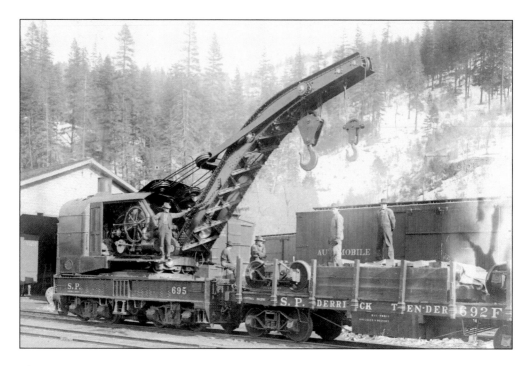

Shown here around 1915, derrick tenders called "hooks" were powerful machines able to lift an entire locomotive. They continue to be used for repairs and on wrecks today. The old car shop in the background was built entirely of wood with two bays. It was replaced with one large enough to service the huge Mallet (cab forward 4-8-8-4 configuration) locomotives in 1939. Pictured below, engineer Tom Brown was killed in this accident when his engine was sideswiped by another engine. The far engine, No. 3273, was built by Baldwin in 1913. (Alan Moder.)

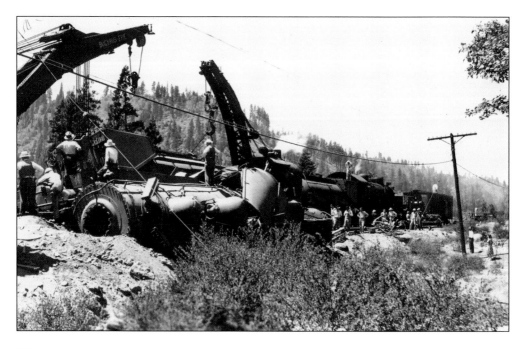

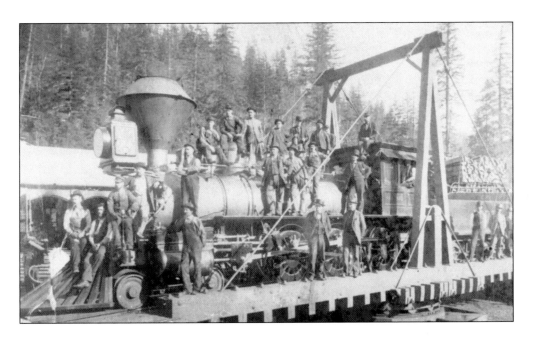

The original 70-foot gallows-type turntable is shown above with an early wood-burning locomotive. It was modified to a 100-foot pony truss turntable in 1915 to accommodate larger locomotives. (Above, Dunsmuir Chamber of Commerce; below, Bruce Petty.)

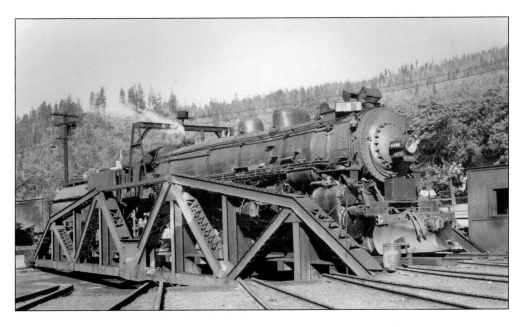

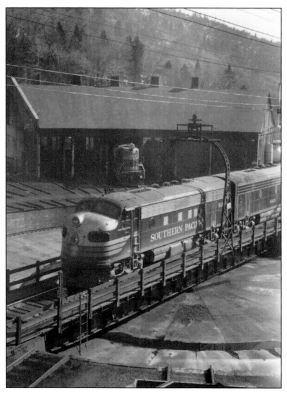

An F-unit utilizes the girder-type turntable that remains today. It was modified and extended to 126 feet in 1939. Common, costly accidents occurred on occasion where turntables were used. More than once, a hostler neglected to set the brakes and an engine cruised right onto the turntable whether tracks were available or not. The remaining six stalls of the roundhouse stand in the background. Most of the roundhouse was removed in the late 1950s to early 1960s. The remaining stalls were used by the City of Dunsmuir. Soon after, they collapsed under heavy snow, and the last portion of a familiar landmark was cleared away. (Left, John Signor; below, Bruce Petty.)

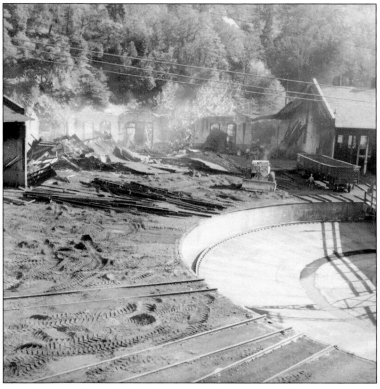

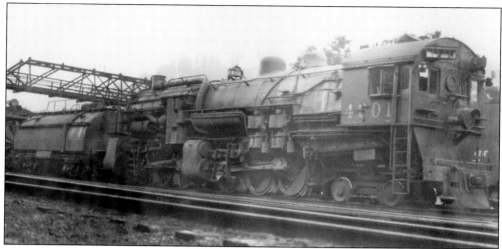

Powerful locomotives called mallets first appeared in 1915. According to the Whyte system of classification, Engine 4201 demonstrates a 4-8-8-2 wheel configuration, meaning it possessed four leading wheels, two sets of eight drivers, and a two-wheel trailing truck. The front and rear wheels were used only to guide and stabilize. The articulated design was an attempt to fit these powerful monsters onto the existing railway. Used heavily as helpers, Southern Pacific abandoned the use of cab forward mallet engines over the Siskiyous when one suffered a boiler explosion due to a combination of design and high-grade angle. The cab forward design was the solution produced by the Baldwin Locomotive Works for Southern Pacific to address the dangerous conditions created when traveling through tunnels. Engine 4201 was built by Baldwin in 1939. (Bruce Petty.)

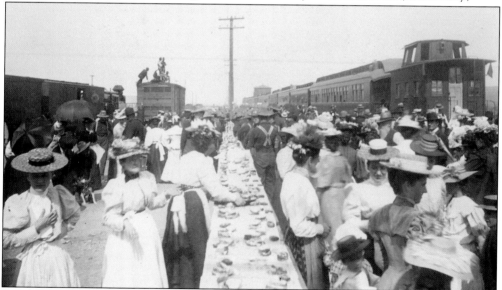

The economy of the railroad reflected America's economy. The Franco-American War and both World Wars stimulated Southern Pacific. Troops needed to be moved, and war increased production of goods. In September 1917, more than 18,000 troops moved through on the Shasta Line in five days. Following the deep cuts of the Great Depression, the Dunsmuir roundhouse serviced more than 1,475 engines per month by 1942. By 1943, traffic had risen to 83 percent of capacity on the Shasta Line. Towns along the railroad were active in supporting troops. Many trains were met with bands and a hot meal. (Siskiyou County Museum.)

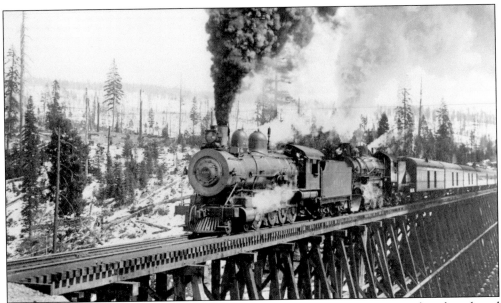

The Big Canyon trestle, located between Mott and Azalea, was over a quarter mile in length and 110 feet high. The old stage road followed underneath. The canyon itself was filled in 1923 when the line changed between Azalea and Mott to the north of Dunsmuir. The westbound Oregon and California Express, No. 16, is shown here. The lead engine is Central Pacific Railway's 4-8-0, class TW 1 built by Schenectady Locomotive Works in February 1895. It was scrapped in 1950. (Bruce Petty.)

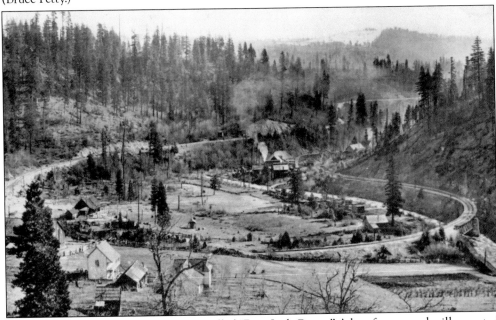

The 14-degree loop at Cantara was also called "Deer Lick Curve." A box factory and mill operated here until the timber was depleted in the early 1900s. Eastbound (away from San Francisco) trains doubled back halfway up the side of the canyon via a similar bend called "Sawmill Curve" in order to leave the Sacramento Canyon. A relative of William Branstetter operated the ranch in the foreground that often housed and fed mill workers. (Janet Crittendon.)

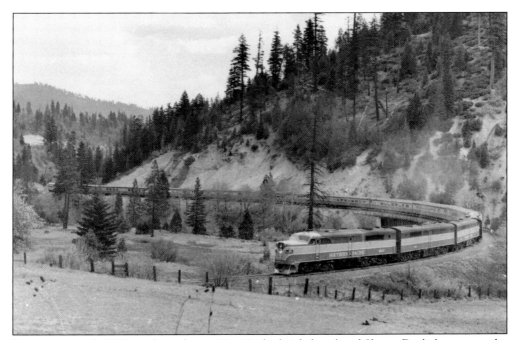

In approximately 1955, eastbound train No. 10, the brightly colored Shasta Daylight, crosses the river for the 18th time at Cantara. Nothing remains of the once-thriving mill and farms but an old fence line and a few fruit trees in the meadow. It is surprising that enough people lived here once to support a post office from 1902 until its closure in 1916. (Dunsmuir Chamber of Commerce.)

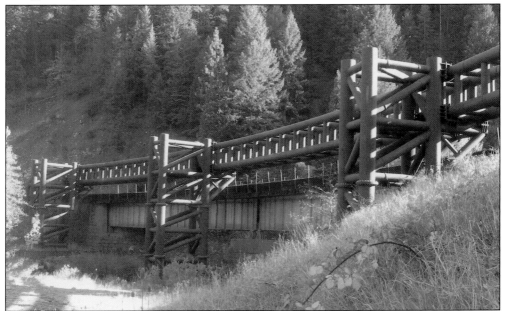

About 19,000 gallons of metam sodium herbicide spilled into the Sacramento River at Cantara in 1991. It killed fish, plant, and animal life downstream for more than 40 miles. Since then, the river has fully recovered. Anglers were actively pursuing their passion in the shadow of the bridge at the time that this picture was taken 19 years later. As protection against future spills, Union Pacific erected this protective structure. (Deb Harton.)

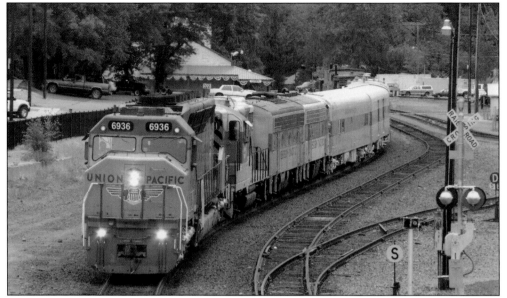

With the conversion from steam to diesel in the 1950s, Dunsmuir, once the largest town in Siskiyou County, suffered. The workforce dropped by 50 percent, and the population of about 5,000 dropped by more than half. In 1996, the Union Pacific Railroad acquired Southern Pacific. Dunsmuir still celebrates the railroad, as seen at the Dunsmuir Railroad Days in 2007 as the Union Pacific (UP) Historic Centennial Locomotive pulls a display train back to the Western Railway Museum in Portola, California. (© Robert Morris Photography.)

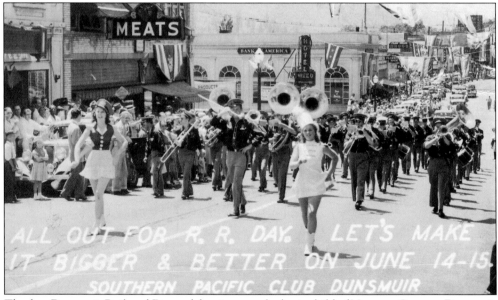

The first Dunsmuir Railroad Days celebration was the brainchild of Norman Green, a Dunsmuir businessman and railroad conductor. Following a meeting of approximately 40 railroaders and businessmen, it was enthusiastically accepted as a way to encourage and interest youth in the railroad, as well as to honor old-timers. The first celebration occurred in 1941. No events were held during World War II. Railroad Days resumed in 1947 and was celebrated for the following 18 years. The halcyon days of the celebration occurred in the 1950s. (Alan Moder.)

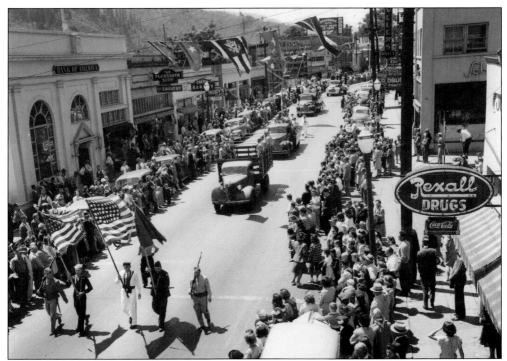

Strongly supported by Southern Pacific, Railroad Days hosted many speakers including president Mercier and vice president J. W. Corbett, a Dunsmuir pioneer. In 1951, an estimated 20,000 people attended Railroad Days. By 1955, steam had mostly disappeared, and with it much of Dunsmuir's significance as a railroad town. River Days and Canyon Days both replaced Railroad Days for a few years, though Railroad Days has been celebrated for 25 of the last 27 years. Today Railroad Days has taken on a more informative and educational tone. The railroad was and still is celebrated in Dunsmuir anytime, including Easter, as these enthusiastic women demonstrate in 1949. (Above, Shasta Division Archives; below, Linda Price.)

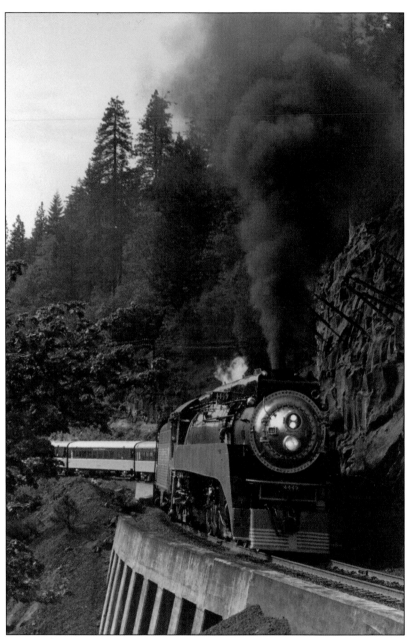

Dunsmuirites and railfans all over the world host a special fondness for 4449. Built by Lima Locomotive Works in 1941, it is the only surviving example of a GS-4 (Golden State/General Service) class of steam locomotives. The "Daylight" was retired in 1957 and remained on display in Oaks Park in Portland, Oregon, until 1974 when it again entered service, sporting a patriotic paint scheme as the "Freedom Train" that celebrated America's bicentennial. Originally sporting the bright orange and red of the Coast Daylight route running between San Francisco and Los Angeles, it has been repainted into daylight colors and continues to make rare appearances. A most memorable experience for Dunsmuir and railfans alike occurred on Labor Day weekend 1991, when a complete Daylight train ran from Redding to Mount Shasta City, promoting a Dunsmuir recently affected by tragedy. (Bruce Petty.)

Four

THE FOUNTAIN, THE WATER, AND THE NAME

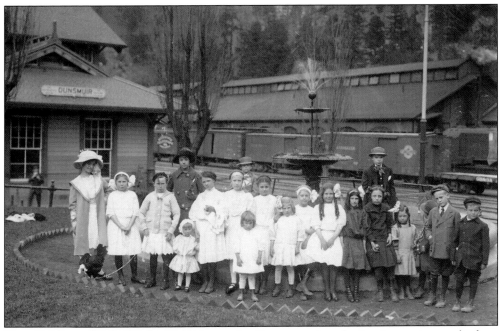

The cover image for this book is a vivid example of how, over time, fascinating stories can slip from memory and be lost to future generations. There is a story in this c. 1910 photograph that we can only guess. Eighteen children and two adults, all dressed in their finest—pretty white dresses for the girls, and coats and ties for the boys. They pose semiformally around the Alexander Dunsmuir fountain with the train yard and the Dunsmuir Depot behind them. One of the women holds what appears to be a stuffed animal . . . rabbit? A girl on the right side (fifth from the right) holds something in her hand. Eggs? And a girl on the left side holds a leash connected to something. A beribboned fowl? Was it a Sunday school class posing for their picture in their Easter Sunday best? One can only be amused by the whimsical image and wonder. Water has had a powerful influence on Dunsmuir. The water of the Sacramento River is what drew Native Americans to the bountiful salmon runs. Anglers today come to fish the very same waters. Water from the sweet and pure springs was an attraction to early explorers and settlers. The mineral springs and their claims for healing properties brought tourists from far and wide. Dunsmuir loves its water and proudly proclaims it to be the "Best Water on Earth." And the story of the fountain is one of Dunsmuir's favorites. (Alan Moder.)

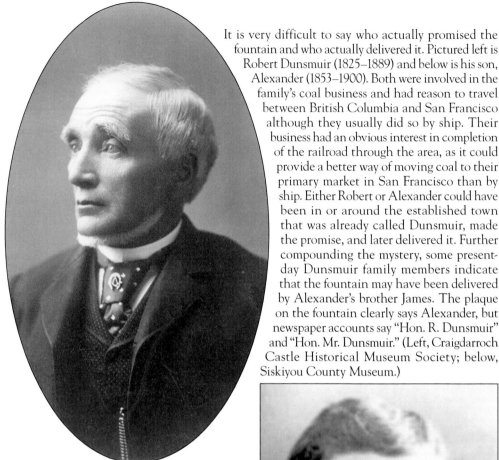

It is very difficult to say who actually promised the fountain and who actually delivered it. Pictured left is Robert Dunsmuir (1825–1889) and below is his son, Alexander (1853–1900). Both were involved in the family's coal business and had reason to travel between British Columbia and San Francisco although they usually did so by ship. Their business had an obvious interest in completion of the railroad through the area, as it could provide a better way of moving coal to their primary market in San Francisco than by ship. Either Robert or Alexander could have been in or around the established town that was already called Dunsmuir, made the promise, and later delivered it. Further compounding the mystery, some present-day Dunsmuir family members indicate that the fountain may have been delivered by Alexander's brother James. The plaque on the fountain clearly says Alexander, but newspaper accounts say "Hon. R. Dunsmuir" and "Hon. Mr. Dunsmuir." (Left, Craigdarroch Castle Historical Museum Society; below, Siskiyou County Museum.)

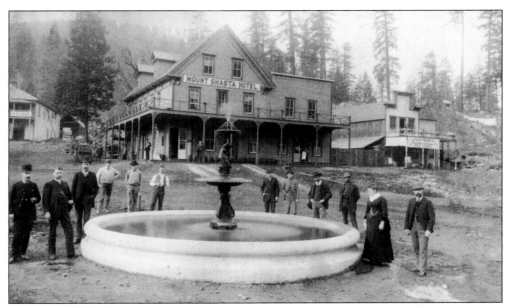

Water piped from the Mount Shasta Hotel sprays from the fountain (above) as a small gathering watches. The October 6, 1888, *Mott North Star* newspaper reported that "Hon. Mr. Dunsmuir, after whom the town is named, has presented a fountain . . . Foundation is being excavated and connecting pipes laid. He also contributed $360.00 toward its erection. Mr. Billicke, hotel owner, will provide water." The lady cast in bronze atop the fountain was still there when the photograph below was taken in 1896. Alexander Levy, the town's first mayor, had his mercantile business in the three-story 1893 Rostel building in the background. When reconstructed after the disastrous 1903 fire, it had (and still has) an iron front and just two floors. The Mount Shasta Hotel was replaced by the Weed Hotel. (Above, Siskiyou County Museum; below, Ron McCloud.)

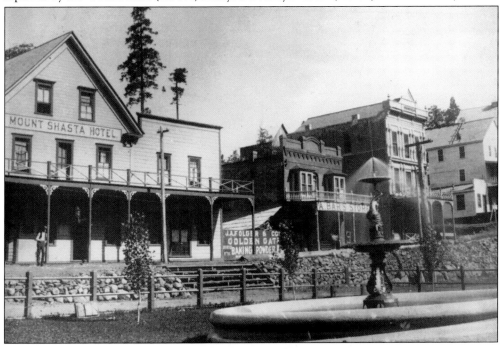

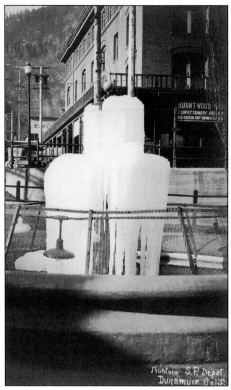

The *Mott North Star* reported on February 11, 1899, that "Dunsmuir's fountain, the town's pride and admiration of all railroad passengers, went down under heavy accumulations of frozen snow and ice weighing several tons. It will be resurrected as it is a thing of beauty in all seasons but more especially in the winter months." Perhaps that was when the lady in the fountain disappeared and a round globe/sprinkler was installed on the top. Large rainbow trout were kept in the basin and a guard fence was erected around it after 1896. Electric light fixtures were added to it later. The wood frame bakery at the top of Pine Street dates this picture between 1924 and 1928. (© Dave Maffei.)

The fountain became a community landmark, a symbol of the town's water resources and a centerpiece for the active railroad yard. It was also a gathering place for railroad workers, travelers, tourists, and residents. It was a cool and shady spot on a hot summer day for these gentlemen to relax and perhaps discuss their fishing success or the politics of the day. (John Signor.)

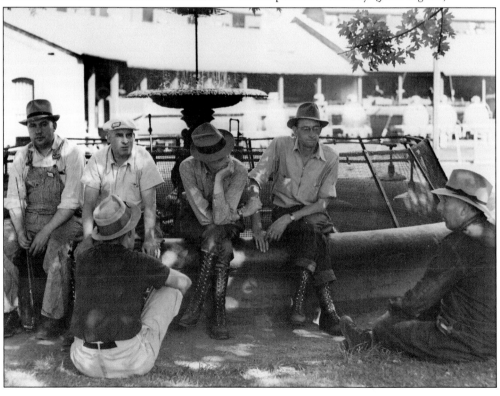

The origin of the slogan "Best Water on Earth" is uncertain, but indications are that the California Oregon Power Company (COPCO) coined it in 1928. COPCO owned the springs and water system that supplied Dunsmuir's water, and the company provided a drinking fountain under this sign at the Dunsmuir railroad station. They also advertised, "The Best Water on Earth is Supplied by COPCO." (Alan Moder.)

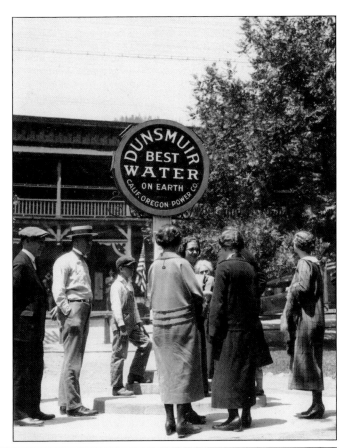

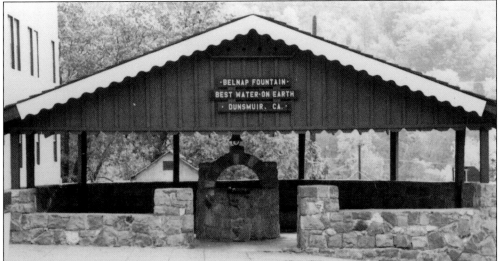

A Dunsmuir Avenue landmark is the Belnap Fountain named for Glen Vord Belnap, a Dunsmuir volunteer fireman who died while fighting a fire in November 1947. The fountain shown here in its original form was dedicated in his memory in 1961. It collapsed in a snowstorm in 1993 but was rebuilt in 1994. Stonework of the original was preserved in the new design. (Dunsmuir Chamber of Commerce.)

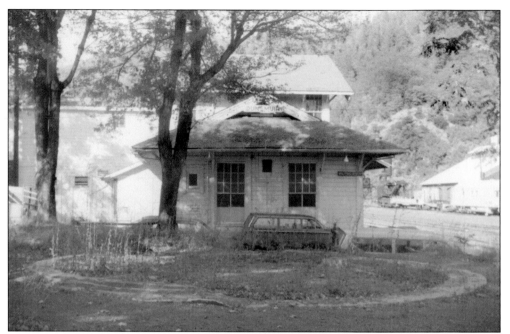

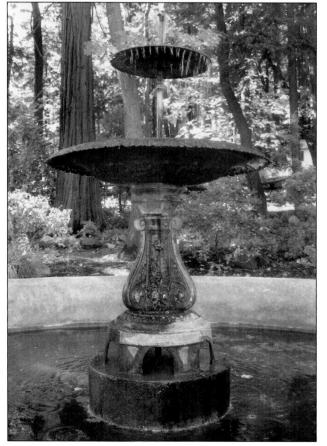

A wistful sadness for the ending of an era is reflected in the derelict car, the weeds, and the mark left when the fountain was removed. It was dismantled in the 1960s by the Southern Pacific Railroad and stored until a new location could be found. The depot was razed in 1974, but the fountain was destined for a new location. (Ron McCloud.)

In the 1970s, a new basin was formed near the entrance to City Park and the old fountain once again flows with Dunsmuir's Best Water on Earth. Today the fountain has an air of tranquility in its shady spot, surrounded by a grove of trees. There is growing interest in restoring the fountain to its original form. The Dunsmuir Rotary Club and the Dunsmuir Botanical Garden hope to even bring back the lady. (Deb Harton.)

Five

RESORTS AND TOURISM

Southern Siskiyou County was blessed with an abundance of natural resources. Thick timber stands abounded, and a variety of minerals were mined. A lavish wealth of natural beauty existed everywhere the eye could turn. Wildlife was plentiful, and the salmon runs were rumored to be so thick that one could almost cross the river via salmon back. Mineral springs were also abundant. Before railroad construction, many inns and stops located near the springs catered to travelers, vacationers, hunters, and fishermen. Entrepreneurs sought these areas to build resorts, which later became stations and/or stops along the rails. From the beginning, the railroad heavily publicized resort areas in order to boost its passenger ridership. Resorts brought commerce and notoriety to the area and people's love for the area has passed to new generations. No less than five resorts—Lower Soda Springs, Upper Soda Springs, Shasta Retreat, Shasta Springs, and Ney Springs—bottled water that was touted as a cosmetic, for its healing powers, or as a refreshment. Resorts flourished on the railroad, then floundered with the increase of automobile tourism. Today, though Dunsmuir's economy remains greatly dependent on tourism, none of these resorts remain. (College of Siskiyous Library.)

51

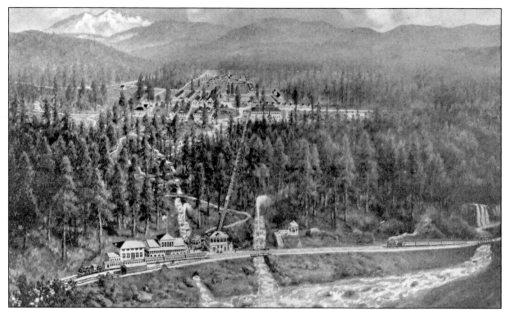

J. J. Scott, partial owner of J. J. Scott and Company's sawmill located on Hedge Creek (north of Dunsmuir), was the first to realize the potential commercial value of the soda springs located on his property. In 1886, he convinced members of a Sacramento wholesale grocery firm, Hall and Luhrs, to develop the area. In December 1889, the Mount Shasta Mineral Spring Company was founded by five individuals, each investing the sum of $500. In January 1890, the *Mott North Star* reported that J. J. Scott and his partners deeded 47.28 acres to the New Company for the sum of $3,000. The condensed illustration above shows the resort in its entirety. The upper cottage system is shown below. (College of the Siskiyous Library.)

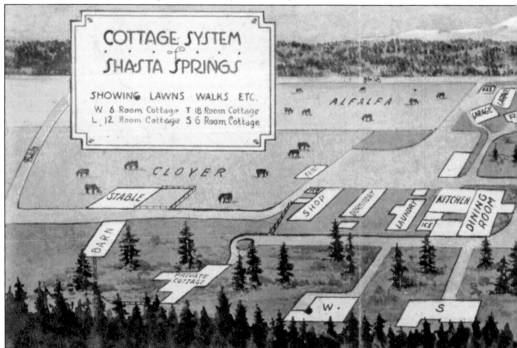

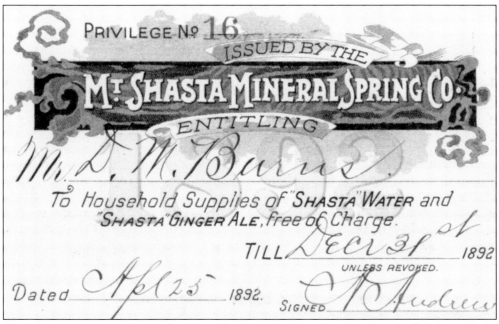

PRIVILEGE № 16

ISSUED BY THE

Mt. Shasta Mineral Spring Co.

ENTITLING

Mr. *D. M. Burns*.

To Household Supplies of "SHASTA" WATER and "SHASTA" GINGER ALE, free of Charge.

TILL *Dec 31st* 1892

UNLESS REVOKED.

Dated *Apl 25* 1892. SIGNED *A M Andrew*

Trains began stopping at Shasta Springs in October 1890. For more than 50 years, Southern Pacific heavily promoted the region as a tourist destination, issuing hundreds of advertisements, postcards, and brochures. The resort was a premier stop along the Shasta Route. The image above shows a privilege granted to D. M. Burns (one of the five shareholders) by president Adam Andrew, who was a Canadian immigrant born in 1858. Along with Thomas Hall, Andrew became one of the five original investors while employed with Hall and Luhrs. He was active in the company, as well as its subsidiaries until his death in 1941 at age 83. (Above, Alan Moder.)

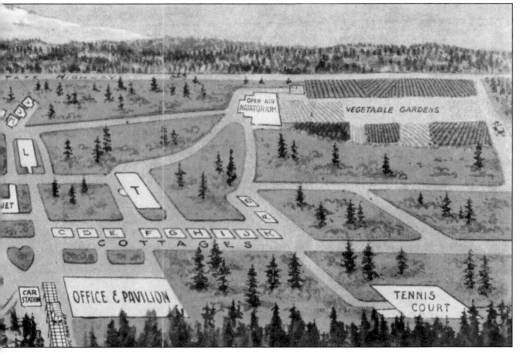

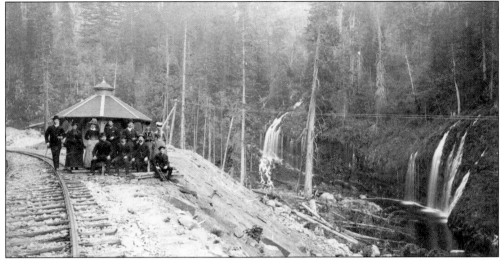

Mossbrae Falls and numerous nearby springs were used for recreational purposes by early settlers and tourists. Native Americans used them for thousands of years before. The *Mott North Star* reported, "The railroad company will soon commence the erection of a summer house . . . at the 16th crossing of the Sacramento River. The house will be octagon in shape, 24 feet in diameter . . . with latticed sides, in the center of which will be a marble urn, into which the water will be conveyed through pipes from the Shasta Spring." Southern Pacific completed the pavilion at Mossbrae Falls in 1888. Trains stopped briefly so that passengers could enjoy the spring waters and striking view. When Shasta Springs opened across the river, trains began to stop there instead. The pavilion fell into disuse and was torn down. (Siskiyou County Museum.)

President Bush visited Mossbrae Falls in July 2004 with Vince Cloward, past director of the River Exchange. He was not the only president to do so. President Harrison stopped for refreshment following his address to Dunsmuir in May 1891. Theodore Roosevelt passed by during his campaign in May 1903. Perhaps Mossbrae played some role in his decision to create the National Park System two years later. And in 1960, John Kennedy passed by after making a whistle-stop campaign speech in Dunsmuir. (Mt. Shasta Area Newspapers.)

Standing in front of the resort's pool, the great granddaughter of Adam Andrew, Elva Lois McKinnnon, was born in 1909 and lived on the property with her family. Her father, Archibald McKinnon, was a carpenter and later superintendent of Shasta Springs from 1889 until his death in 1924. (College of the Siskiyous Library.)

Pictured above around 1898, young Marian Mallory (Bass) sits near the spur in front of the bottling works managed by her father. (Dunsmuir Chamber of Commerce.)

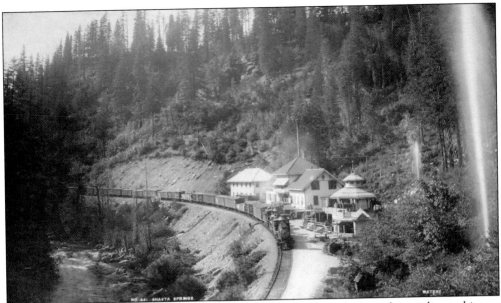

Numerous small springs on the surrounding grounds were cleared. Several were diverted into a main fissure in a clever feat of engineering—by cementing them over with broken bottlenecks used as vents. The bottles were later corked and covered with another layer of cement. A reservoir built over this main fissure was divided into two sections: the open drinking basin for public use and the other leading to the bottling works. Pictured above, the two buildings on the left were reserved for the bottling works. Pres. Adam Andrew realized quickly the cost-effectiveness of shipping water to Sacramento to be bottled there. (John Signor.)

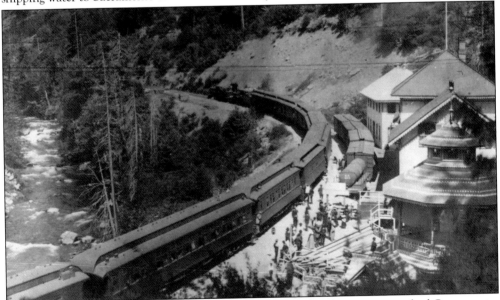

Water shipments began in 1890. Controversy exists regarding how water reached Sacramento. Some say special glass-lined railroad cars were used, although this seems unlikely. Later cars were lined with block tin. Once shipped, the water was sold in 12-ounce capped bottles to 5-gallon jugs. The well-known siphon bottles were used until the mid-1950s. A common phrase during the 1920s was, "I'll have a Shasta and whiskey." (John Signor.)

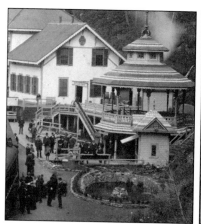
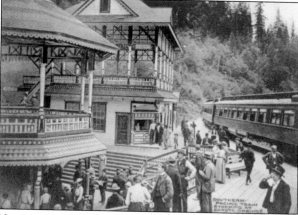

Trains stopped at Shasta Springs for 20 minutes twice daily where spring waters were available for refreshment. Boys sold collapsible cups for 15¢ (25¢ for cups with an image of Mount Shasta on the lid). It must have been a frantic scene when 200 people disembarked and attempted to access Shasta waters at the pavilion. By 1903, the bottling works at Sacramento was inundated with orders. Adam Andrew deeded property in San Francisco to the company for a new plant that became the executive headquarters. The Sacramento plant continued operations and the new plant received Shasta water by rail in the same manner. (Left, © Dave Maffei; right, College of the Siskiyous Library.)

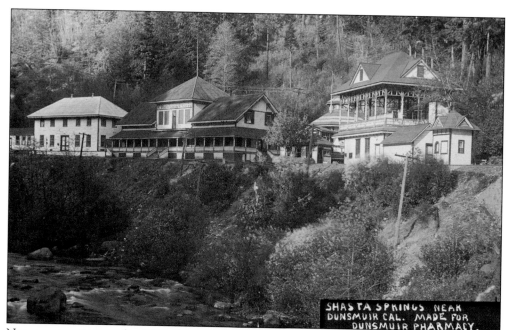

New construction south of the public pavilion was nearly completed and was painted white with dark red trim according to the *Dunsmuir News* (October 1898). The platform of the new incline railway was located on the open top story. The lower story housed a gift shop and the machinery for the tram. The kiosk housing Oxone Springs is further south. (Alan Moder.)

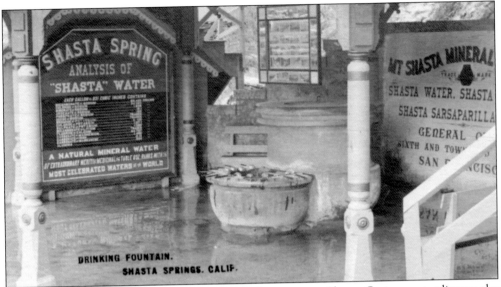

Three springs were located approximately 300 feet apart at Shasta Springs according to the California State Mining Bureau: the Shasta, the Glacier, and the Keystone. "The water has a temperature of 51 degrees Fahrenheit, and contains considerable carbonic acid gas, magnesium, potassium, iron, and a little manganese, lithium, and arsenate." Two additional springs were located in the general vicinity: Glacier Lithia Spring and the Sauer Brennan Spring. The Glacier and Keystone were not carbonated. Of Shasta Spring, J. C. Simmons (in his book *My Trip to the Orient*) noted, "The water is ice cold, and so heavily surcharged with carbonic acid gas, that it flies, sparkling, into the face, and bites the tongue with the most pleasurable sensation. My! But it was refreshing and delightful." (Alan Moder.)

The gift shop catered to tourists, locals, and fisherman alike. Fishing tackle and licenses were sold, as well as refreshments and souvenirs. Shasta Spring water made a refreshing tonic when mixed with lemonade (Archibald McKinnon jotted down a recipe in one of his notebooks using Shasta Water: three cups ginger ale, three cups lemon soda, and four cups Shasta water). The post office operated here from 1892 until 1935. (John Signor.)

Southern Pacific built a new station platform in 1913 costing about $4,000. It replaced the structure that began as the natatorium or bathhouse that was abandoned when a new bathhouse was built up top. It may have served as storage for the dynamos that heated the bath water and provided electricity to the entire hotel system. Adam Andrew was involved in many aspects of the construction of the new station by Southern Pacific. (Alan Moder.)

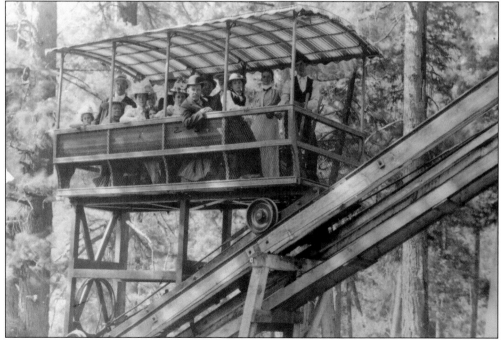

The *Dunsmuir News* reported the water-powered, 45-degree incline railroad was making regular trips in July 1898. The tram was 640 feet long, covered a vertical rise of approximately 300 feet, and was later classified as the shortest railroad in the world. The tram passed through heavy forest, laden with tiger lilies and wild azaleas in the spring. The cost to ride was 5¢. The charge for luggage was 25¢, and guests rode for free. (John Signor.)

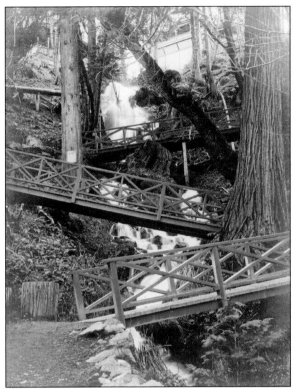

The Zig Zag trail was the other option for reaching the hotel from the railroad station. The trail traversed back and forth over Glacier Falls in a series of steep switchbacks. Many benches were built along the trail so that climbers could rest. Constructed in May 1890, this trail was the only means of travel between the station and hotel until the tram was built. It remains intact today, looking much the same. (Siskiyou County Museum.)

The Shasta Springs Hotel Company was also accessed by Old Stage Road, later Highway 99. Attractions included maid service, a 150-foot-by-30-foot swimming pool (unheated with a depth between 4 and 8 feet running lengthwise), tennis, and croquet. Water for the hotel system was pumped from the Keystone Spring. Operating between May and September, a cottage, including maid service and meals, rented for $10 per week in the early years. (Alan Moder.)

A cottage and a parcel of land were deeded to each original director. Adam Andrew's cottage overlooked the Sacramento River. Just south of the hotel system, W. F. Herrin, top legal counsel for the Southern Pacific Railroad, built a summer home named Wildwood in 1903. Railroad officials, Tom Mix, Shirley Temple, and John Muir, were but a few of his guests. His private railroad car, also named Wildwood, was sided at Shasta Springs. (John Signor.)

The Mount Shasta Mineral Springs Company became the Shasta Water Company in 1928 when it was sold for $461,361. In February 1935, the company reported a 25 percent increase in sales and increased shipments of water correspondingly. The renewed interest prompted many, much needed repairs: a remodeling of the pumping and storage facilities, restructuring of the trails and bridges, construction of a new dining facility, improvements to the pool and tennis courts, and even the installation of golf links was planned. Reconstruction went wildly over budget, and with more improvements needed, it may have contributed to the future financial troubles of the company. (Alan Moder.)

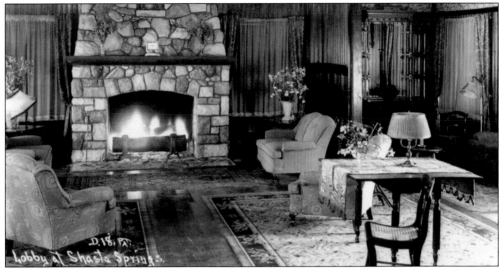

The year 1941 marked a shift in the focus of the company with the death of founder and chairman of the board, Adam Andrew. Finances and morale were stretched further when extensive and costly repairs to the floundering hotel went over budget. During World War II, the government denied an increase in sugar rations, and the company was forced to purchase lower grade sugar at higher cost. Shortly after this picture was taken, the Shasta Water Company began to sell holdings to the Saint Germain Foundation, a religious organization having origins near Mount Shasta. The first sale occurred following World War II. The $230,000 sale allowed the company to continue operating as the Shasta Beverage Company without its connection to Shasta Springs. (Deb Harton.)

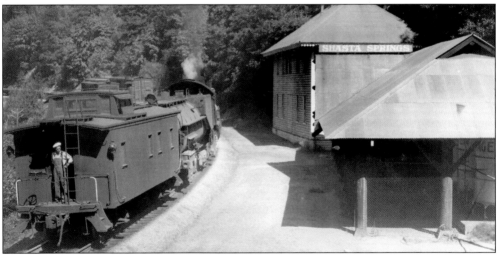

The Shasta Springs Station was retrofitted in 1937 by adding holding tanks for shipments, but plans changed following World War II. The Herrin Estate was sold to the Saint Germain Foundation in 1957, and the Shasta Water Company sold the last 10 acres in 1958 to the same foundation. Both sales shocked the community, because they thwarted plans for a veterans' convalescent hospital and an elementary school. Today the upper portion of Shasta Springs remains privately owned by the Saint Germain Foundation. Nothing remains below, though if one looks hard enough, a small basin out of which famous Shasta Springs water continues to run might be located. (John Signor.)

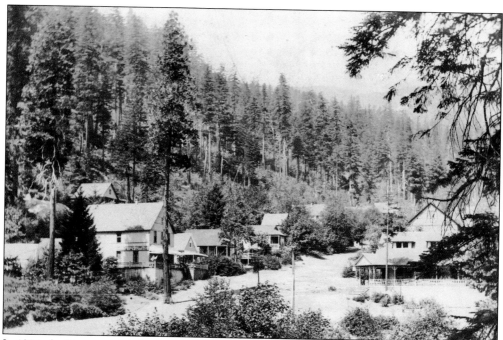

In 1894, the Dunsmuir Methodist Episcopal Church established Shasta Vicino Camp Association. Ministers promoting the plan acquired 240 acres just off State Highway 99. Streets were laid out and named for the ministers—Gray, Hart, Wells, Needham, and Isgrigg. Stock was sold to finance the building of cottages, bridges, a hotel, tabernacle, store, and pool. The above view of Simpson Avenue shows Shasta Retreat at its height as a popular destination for vacationers. Families purchased lots and erected cabins—some of which are still owned by these same families. Much of the original property was sold to private parties and evolved into a residential area. The portion of the retreat closest to the river and the station, then referred to as the Palisade Addition, is today known as Shasta Retreat. (Above, Siskiyou County Museum; below, Alan Moder.)

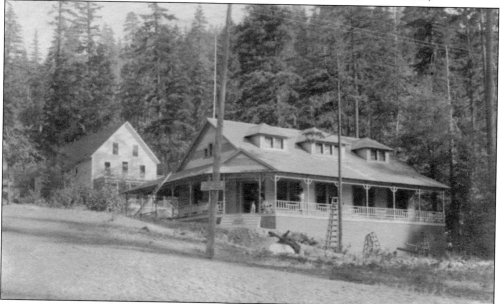

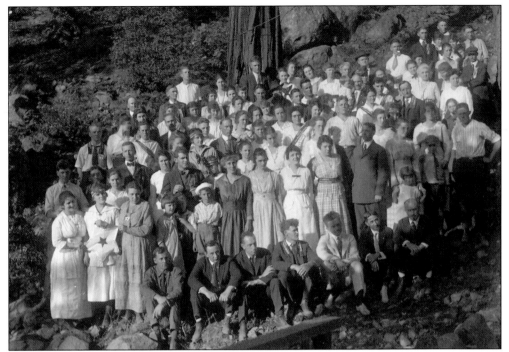

The Epworth League Institute was a youth order of the Methodist Episcopal Church founded in 1889 to provide religious guidance to young church members. Camp meetings, shown here around 1919, were an important part of their summer activities. Concerts, lectures, and sermons were provided for guests, and it was an ideal assembly area with its mild summer climate, wholesome atmosphere, and easy access by train. (Ron McCloud.)

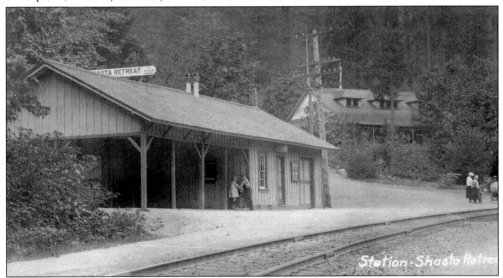

The Southern Pacific Railroad opened the Shasta Retreat Station on January 1, 1896, 1.25 miles below Shasta Springs and three-quarters mile above Upper Soda Springs, at the mouth of Bear Creek. Visitors to the retreat used this station from June through September each year until passenger service was dropped in 1937. A round-trip fare from San Francisco was $12.15 at the turn of the century. The station was removed in 1938. (Alan Moder.)

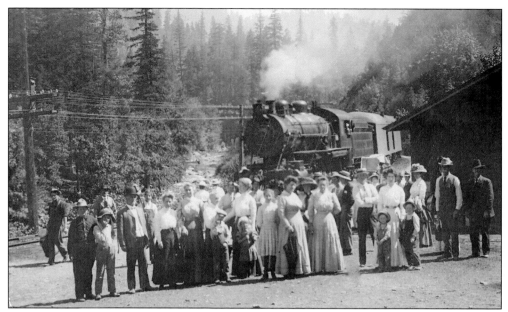

Families and groups who came by train to Shasta Retreat enjoyed the cool climate and excellent fishing. Private summer homes and a resort hotel brought vacationers in large numbers. A bridge, at this point, connected the portions of the retreat on the east and west banks of the Sacramento River. The Oregon Express left San Francisco at 8:20 p.m. and arrived at the retreat the next morning. Visitors were encouraged to not arrive or leave on Sundays so there could be a "quiet and restful Sabbath." (Alan Moder.)

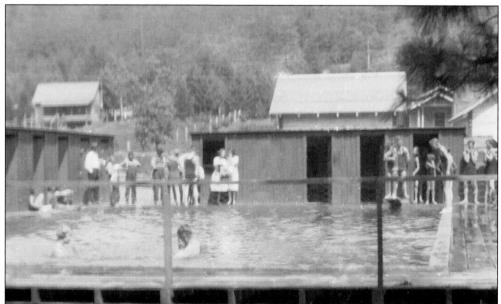

Dr. Benjamin Gill, one of Dunsmuir's early physicians, built a swimming pool on the bank of the Sacramento River at Shasta Retreat referred to as a various level swimming tank. A 7,000-pound boiler provided steam heat. Dr. Gill was noted for peddling a four-wheeled bicycle that could run on the railroad tracks between his practice in Dunsmuir and the retreat to check on his public pool. (Ron McCloud.)

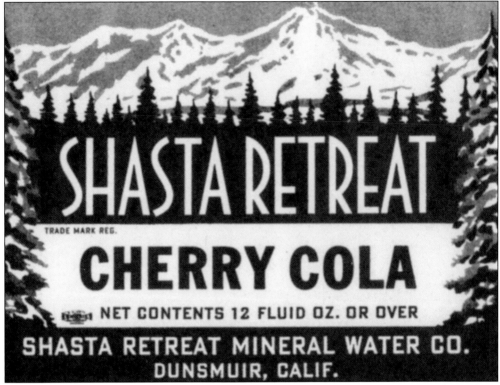

In 1936, Charles Pendleton and his son, Errol, began bottling mineral water taken from three springs on their property in Shasta Retreat. Water was chilled to 35 degrees and carbonated prior to packaging and shipping at a rate of 150 cases per day. First called Sparkling Retreat Mineral Water, it was later changed to Shasta Retreat Mineral Water and marketed with different flavors. (Alan Moder.)

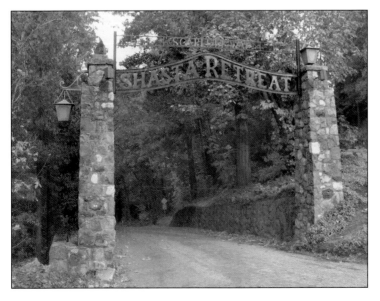

Still a landmark at the entrance to Shasta Retreat, the arch designating the name Scarlett Way was built in 1926 by Alice Scarlett as a memorial to her husband, James. He owned a cabin in the retreat and built and maintained the road at his own expense. The arch originally cost about $500. It was demolished by a large truck in 1943 but was rebuilt. (Deb Harton.)

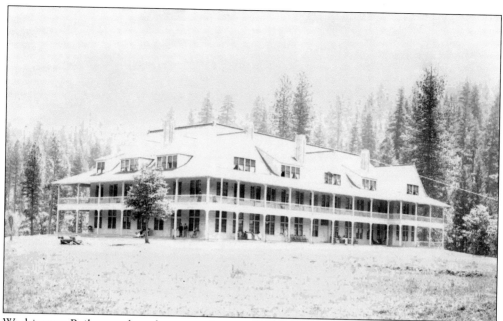

Washington Bailey purchased property just south of Dunsmuir, including Upper Soda Springs, from squatters in 1858. He granted Southern Pacific a right-of-way for the future railroad in 1881 and later sold a portion to the Pacific Improvement Company (PIC), which managed the railroad's properties, in 1884. Construction began on what would become the most prestigious of resorts, the Tavern of the Crag. The 210-room building was E-shaped, and was furnished like an old English tavern with electricity and hot and cold water available to each room. It was rumored to have cost over $50,000 to construct. Below is the gazebo currently housing the soda spring located on the property. (Above, Alan Moder; below, anonymous.)

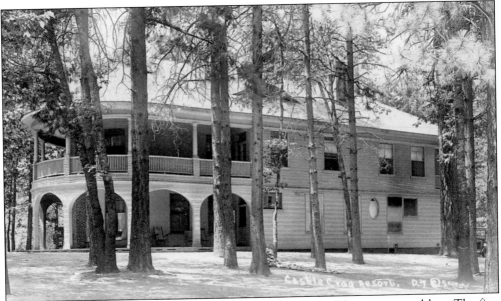

In July 1900, the tavern burned. No lives were lost, but the building was a total loss. The fire, thought to be electrical in nature, started in the steam laundry attached to the main building by a breezeway that seemed to fan the blaze. Fire equipment on location was not functional, and a fire train sent from Dunsmuir arrived too late. The fire burned so hot that a piano moved 40 feet away suddenly burst into flames. Abijah Cahow, the stepson of Robert Hanlon who operated Hanlon's (an old stage stop) directly to the north, leased the property in 1903 to operate as a summer resort. It never regained the glory of those early years. The structure above, built by the PIC in 1905, looks much the same today. It is called the Berry Estate and is owned by family descendants. (Alan Moder.)

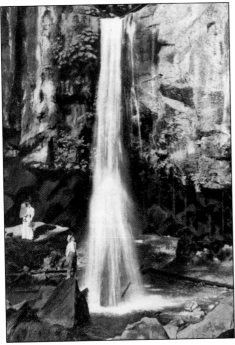

Ney Springs, another resort focused on mineral waters, Castle Lake, and Hedge Creek Falls are other nearby natural landmarks. Hedge Creek Falls, once rumored to be a hideout of the infamous Black Bart, is located off Interstate 5. The water falls 30 feet over a dramatic basalt face with a cave and path behind it. It continues to be a place of interest due to Marie Wehrheim Reid, whose family owned the land before California purchased it, and, in the early 1970s spurred residents to action and saved the falls by relocating Interstate 5. (Deb Harton.)

Six

THE OPEN HIGHWAY

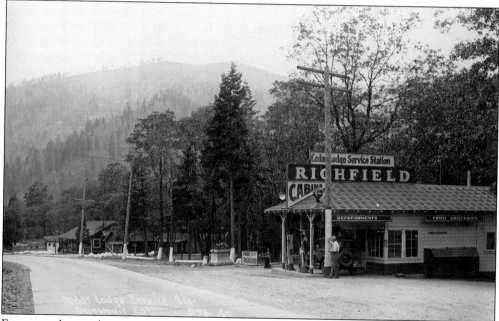

For a population that was accustomed to train travel, the automobile presented a whole new freedom. No longer tied to a time table with specific arrival and departure times, and no longer restricted to a set travel route, families in their new automobiles were free to explore and venture into the wide open spaces at their own pace. Vacations became adventures. Highway 99 brought people to Dunsmuir to experience the mountain environment, fishing, and opportunities for a change in lifestyle. Many traveled through, and others came and stayed. New residents brought new businesses, skills, and energies, which shaped Dunsmuir into a vibrant community that was no longer as remote as before. Dunsmuir was the first large town north of Redding and the ideal place for travelers to stop. Auto camps were the predecessors of motels. They were affordable, convenient, and often scenic places that helped make travel by automobile popular. (Alan Moder.)

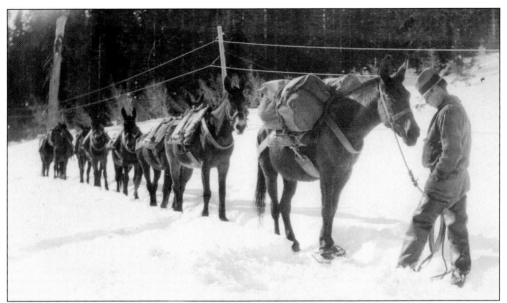

Before completion of a passable wagon road up the Sacramento River Canyon, sure-footed mules were relied upon to traverse the rugged trail. The state legislature granted a franchise to James L. Freaner in 1852 to build a wagon road along the Sacramento River to Oregon. Freaner died before the road was finished and it was ultimately completed by Ross McCloud of Upper Soda Springs. Travelers could get to Upper Soda Springs by mule trains, often fitted with snowshoes for winter passage. Beginning in 1858, travel from Shasta to Yreka was possible by stage such as this one shown at Forest Mountain. Lag and Kenyon's Stage Line ran daily from Shasta to Yreka, but the middle 40 miles from Pit River to Soda Springs was by mule. (Siskiyou County Museum.)

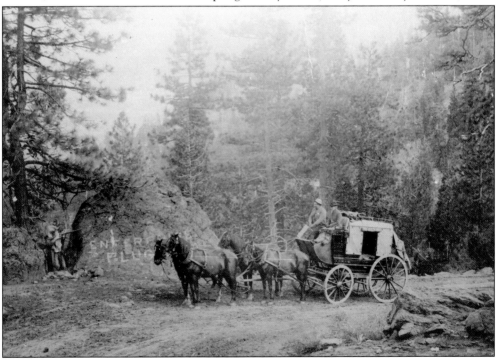

California started automobile registration in 1905, and in 1909, the state legislature laid the foundation for a unified state highway system. What would in 1912 become State Highway 99 and in 1926 U.S. Highway 99 was originally called the Pacific Highway (as opposed to the Pacific Coast Highway 101). It roughly followed trails used by native people, early trappers, and freight wagons up the Sacramento River Canyon. Shown here approaching Castle Crags (right), it continued on to pass through Dunsmuir, following Florence Avenue (now Dunsmuir Avenue). Traveling Old Stage Road under a railroad trestle between Sisson and Dunsmuir (below), this motorist is one of many who chose to give up the comfort of train travel for the freedom of his automobile. This dirt road was typical for the time and travel was rough. (Right, Deb Harton; below, Alan Moder.)

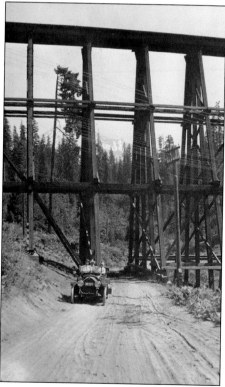

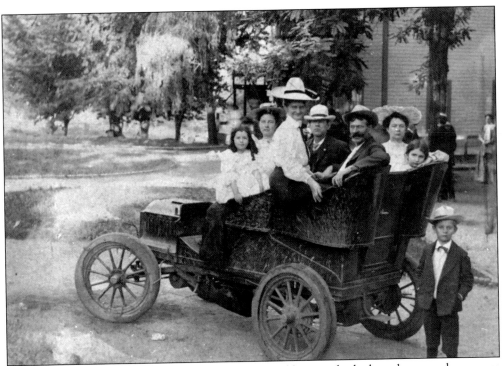

An old joke in Dunsmuir is that the first parking problem resulted when the second car came to town. Shown here is the second car—a 1904 Oldsmobile owned by Fred Mallory, who drew a crowd to see if he could negotiate the steep Pine Street hill. He did. In the photograph above, Mallory, with his wife and daughter (Marian Bass, née Mallory), pose in the back seat. The popularity of the automobile is obvious (below) in this 1920s gathering of motoring enthusiasts at the east end of the Butterfly Avenue Bridge in front of the Dunsmuir Garage. Goodrich tires must have been popular to deal with the unpaved roads of the day. Dunsmuir's undrivable street is shown here—the stairs of Bush Street go up the hill to the right. (Above, Dunsmuir Chamber of Commerce; below, Ron McCloud.)

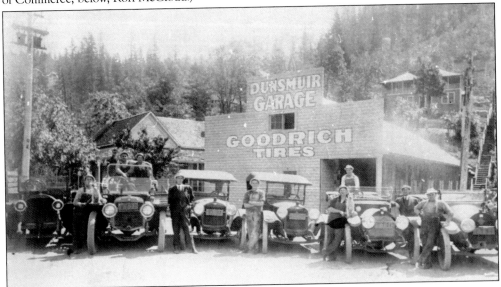

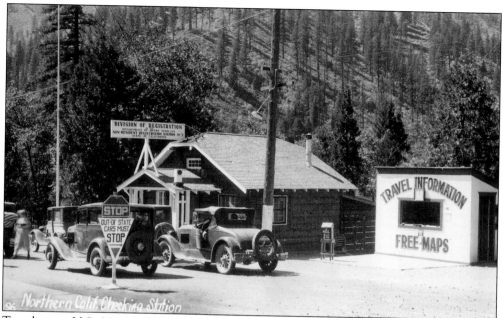

Travelers on U.S. 99 passed through the inspection station which began operation in 1928. Located near the road into Shasta Retreat, it registered out of state visitors, collected statistics, and watched for stolen cars. While they were stopped, motorists were encouraged to pick up maps and information on the area. The December 6, 1929, *Dunsmuir News* reported that 100 cars per day were being registered. (Deb Harton.)

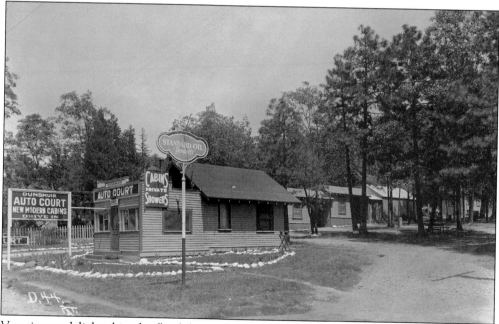

Vacationers delighted in the flexibility and romance of touring the open road. In early 1922, Dunsmuir leased out property to a private party in order to create Dunsmuir Auto Court. The goal was to draw tourist dollars into town, provide camping cheaply (35¢ per night) and possibly to thwart the trespassing on private property that often resulted. (Alan Moder.)

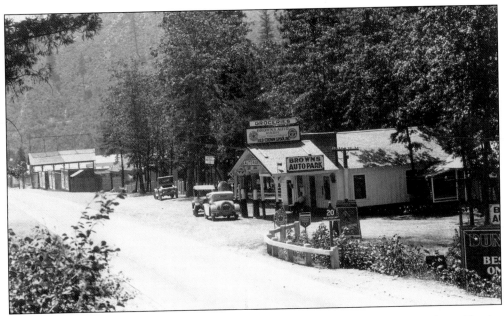

The Brown's Auto Park property was purchased by Charles and Ida Mae Brown from Charles Masson in 1922 for $2,500. Showers, toilets, six rustic cabins, and tent platforms were constructed. During the depression, a hot shower and firewood cost 50¢, and the rental of a cabin was a $1 to $1.50. The death of Charles Brown and World War II fuel rationing caused the park to close. In 1946, entrepreneurs from Walnut Creek, California, purchased the park for $42,000. The second generation of Dewey's continues to operate the motor hotel under the name of Cave Springs Resort. Cave Springs, or Spring Cave, was the name the Native Americans gave the location many years before. (Alan Moder.)

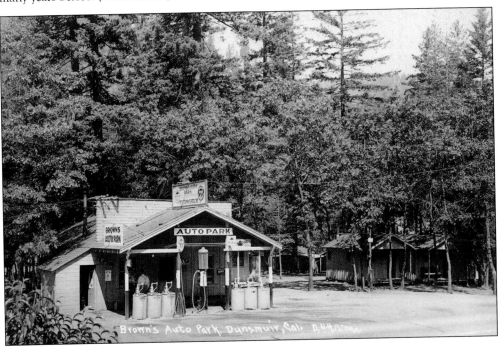

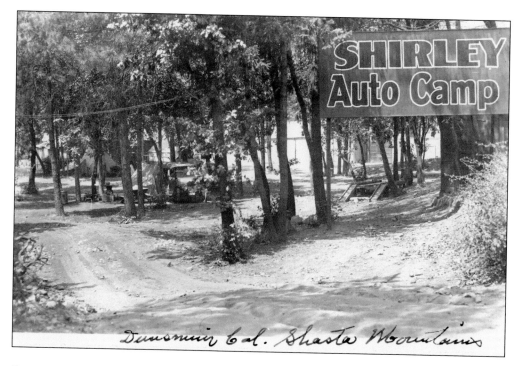

Dunsmuir Cal. Shasta Mountains

Driving clubs became popular around 1910. The price of a new Ford dropped to about $525 in 1913. By 1929, California had the highest number of vehicles per capita in the country. Highway 99 north of Dunsmuir could have been called "Camper's Row." In 1928, Dunsmuir hosted no less than seven camps catering to the automobile tourist. Most were located north of town on what is now Dunsmuir Avenue. The office of Shirley's Auto Camp, located just south of Cave Springs, still stands. Most vacationers tired of the novelty. Traveling families began to demand more amenities such as real beds, heat, entertainment, and cooking facilities. Auto camps gave way to auto parks, and were the precursors of the motor hotels (motels) of today. (Alan Moder.)

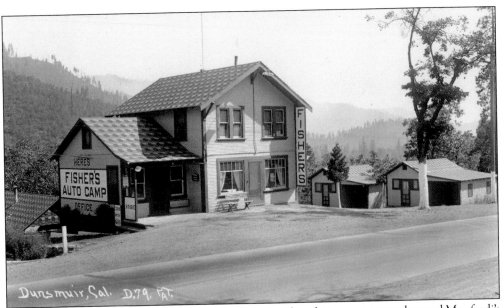

Nothing remains of Fisher's Auto Camp today but a few foundations, an empty lot, and Manfredi's Food and Gas Depot. The Fishers sold their downtown restaurant, Fisher's Electric Grill, in 1927 to develop a campground. Marian Bass was the second generation managing Fisher's, which she did for 28 years. The residence shown here was built during this time. Several of the fishing cabins were torn down in the early 1970s when the Manfredi family purchased the property. (Alan Moder.)

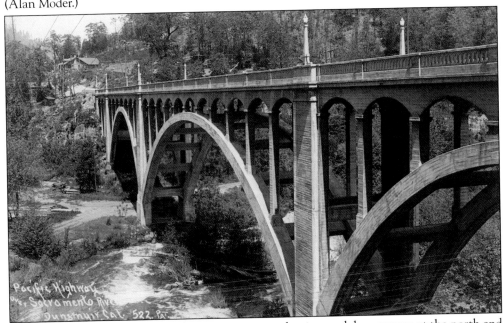

Although designed and built simply as a way to cross the river and deep canyon at the north end of town, the Dunsmuir Bridge is an example of those built by state bridge engineer Harlan D. Miller. His graceful, reinforced concrete arch bridges enhanced their natural setting. Although modified from its 1916 design and now masked by the addition of a parallel structure, the Dunsmuir Bridge is still in use after more than 90 years. (© Dave Maffei.)

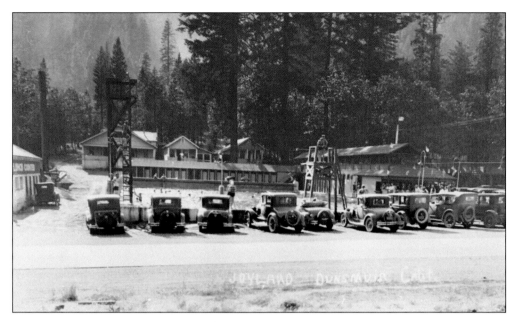

Motorists passing through Dunsmuir on Highway 99 drove past the Dunsmuir swimming pool and perhaps were tempted to stop for a refreshing swim. Constructed in 1928, it was originally part of the entertainment complex called Joyland. No fence enclosed the pool with its original wooden diving towers (above) but the dimensions, 25-yards-by-50-yards, are unchanged today. Joyland closed after 1938, and the pool sat unused until 1947. Public donations and funds raised by the Dunsmuir Lions Club helped to buy the pool and pay its initial operating expenses managed by the Dunsmuir Recreation District. With the arrival of Interstate 5 in close proximity to the pool, businesses and residences across the road (below) were removed and the street that runs to the east is no longer there. (Above, Dunsmuir Chamber of Commerce; below, Alan Moder.)

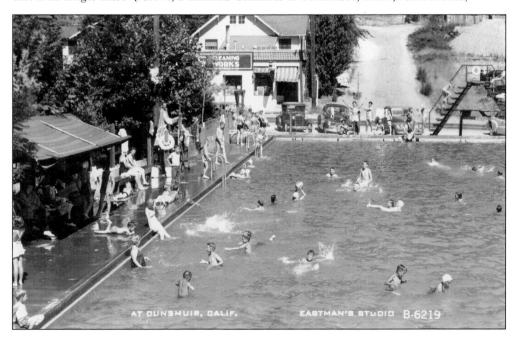

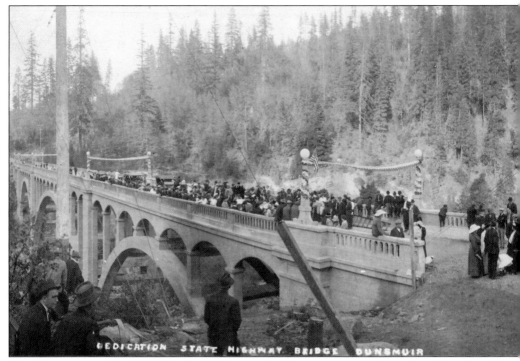

Opening ceremony for the bridge in 1916 was a significant event as it linked north and south Dunsmuir and opened the Pacific Highway to a more direct route. Most everybody in Dunsmuir attended the festivities, which included a marching band and visiting dignitaries. It was an

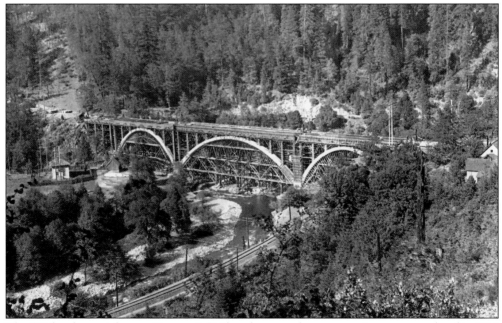

The 579-foot-long triple span Dunsmuir Bridge, shown under construction, was completed in 1916 at a cost of $45,418. The bridge spanned both the Sacramento River and the Southern Pacific Railroad tracks. (Ron McCloud.)

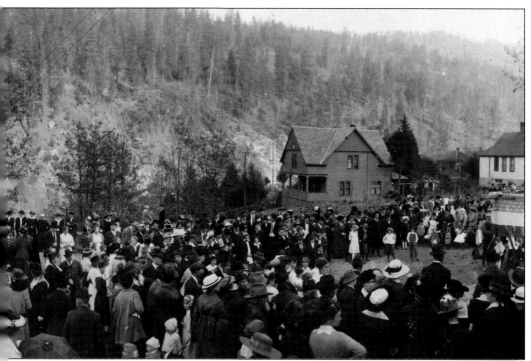

opportunity to walk across the bridge, look over the side to the river below, and witness the first automobile crossing. (Siskiyou County Museum.)

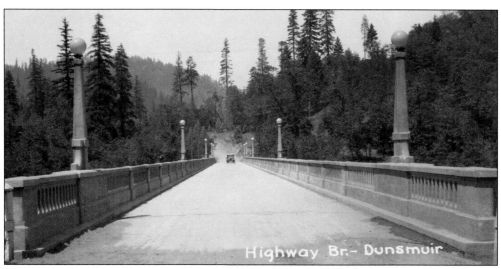

The new bridge did not have a pedestrian walkway, but it was added in 1929 at a cost of $6,550. The attractive light standards with round globes rising above the railings accented the graceful design. The bridge was very effective in connecting north Dunsmuir with the southern part, but as the volume of traffic increased year by year, its narrow deck proved inadequate. It was widened in 1953–1955 by adding a parallel structure sharing a common deck, and by eliminating sidewalks, railings, and light standards. These improvements cost $698,422, almost 15 times the cost of the original structure. (Ron McCloud.)

Improvements to U.S. 99 began in 1952 in preparation for widening the Dunsmuir Bridge by constructing a parallel span. The pedestrian walkway and lampposts on decorative stands above the railing would be eliminated with the new structure. Ultimately the bridge would become a part of Interstate 5, and Florence Avenue traffic was routed over a new bridge to the west. Runaway trucks southbound on the downhill curves approaching central Dunsmuir were a severe hazard. Urgency to remove heavy commercial traffic from Florence Avenue was intensified in 1957 by the crash of a plywood truck in central Dunsmuir that caused two deaths. Straightening the curves (below) and widening the road were necessary steps that brought major changes to Florence Avenue. Beyond the bridge is the new grade eliminating the curve toward the Dunsmuir Ball Park and the Corral Resort. (© 1953 California Department of Transportation.)

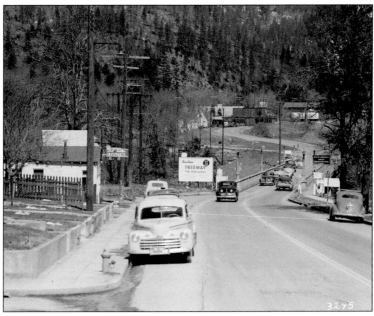

Seven

BUSINESSES

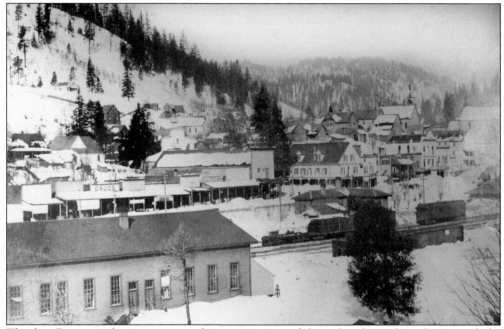

The first Dunsmuir businesses arrived in anticipation of the railroad, supplying basic needs for workers and their families from tents and wagons. Wood was plentiful, and as the railroad built its shops, depot, and roundhouse, businesses built their storefronts, offices, and warehouses. As in many small towns across the country, fires have played a major role. Nearly all of the wood-framed buildings along Front Street (Sacramento Avenue), shown in this winter scene, burned on April 5, 1903. Reconstruction began immediately, however, and Dunsmuir's commercial district survived and was stronger than before. With the arrival of the automobile and U. S. Highway 99, the "Back Street" (Florence Avenue) began to shift from residential to commercial. But another major fire on April 25, 1924, took homes, businesses, and churches on that street. Again reconstruction was rapid, and Florence Avenue began to evolve into the main commercial street. (John Signor.)

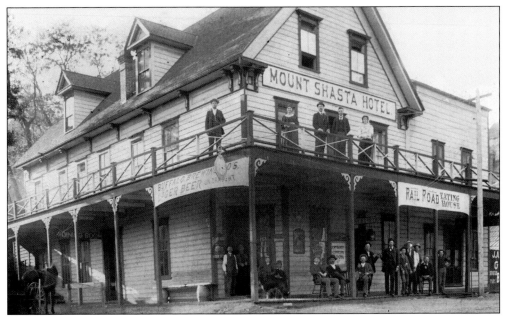

The 1903 fire that burned so much of the business district started in the top floor of the 2.5-story Mount Shasta Hotel near a heating duct. The entire block of businesses on Sacramento Avenue between Cedar and Pine Streets and a third of the block north of Pine Street burned as did most of the private residences on both sides of Florence Avenue between Pine and Cedar Streets. The hotel was completely destroyed in the fire. In the dramatic picture below, firefighters have good water pressure to wet down buildings in the path of the fire. Hoses were run from the railroad yard to Sacramento Avenue, and the *Dunsmuir News* reported that firefighters "worked manfully." (Above, Siskiyou County Museum; below, Paul Carter.)

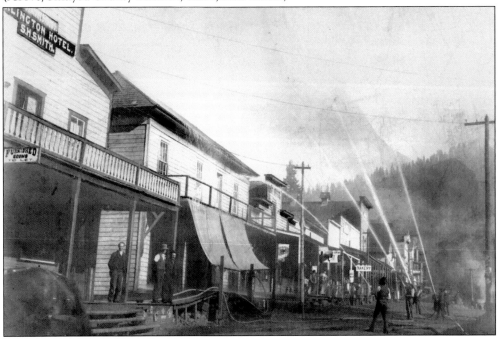

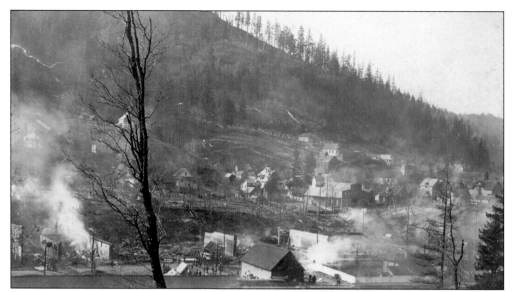

On Sunday morning, April 5, 1903, the still smoldering debris (above) from the worst fire in Dunsmuir's history added to the scene of desolation. The remains of the California Hotel on the south side of Pine Street (below) include several bathtubs and other hotel fixtures in the rubble, while various furnishings and boxes of liquor from the hotel bar and other nearby businesses are stacked in the street. Just six days later, the *Dunsmuir News* reported that new buildings were being erected and arrangements were made to continue operating out of tents, warehouses, and temporary buildings. The Mount Shasta Hotel—where the fire started—opened a kitchen and dining room in the railroad's car shop the day after the fire. (Above, Bruce Petty; below, Ron McCloud.)

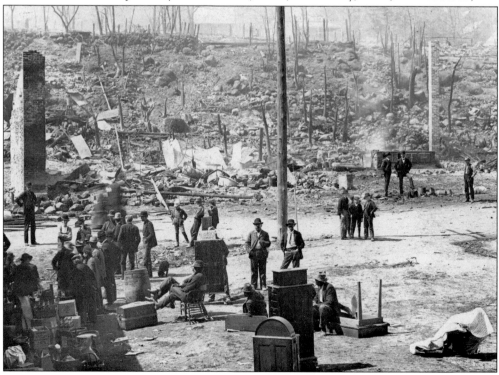

The 1903 fire stopped at the Rostel Building just to the left of this photograph. Sacramento Avenue buildings seen here, which did not burn, are, from the left, *Dunsmuir News* office, Knights of Pythias Hall, and Riverside Hotel. Three churches are visible: the Methodist Episcopal (behind the Riverside Hotel), Catholic (upper center), and St. Barnabas Episcopal. The house of the railroad section boss is across from the Riverside Hotel. (Siskiyou County Museum.)

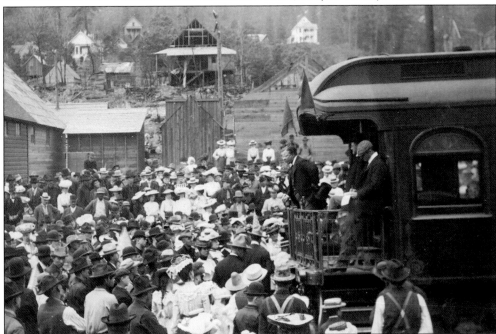

One month after the fire, Teddy Roosevelt spoke to a crowd from the back of a railroad coach. A transcript of his speech exists (his secretary can be seen taking notes) and it is interesting that he made no mention of the fire that had nearly destroyed the town, even though he spoke in plain view of the destruction and rebuilding. (Siskiyou County Museum.)

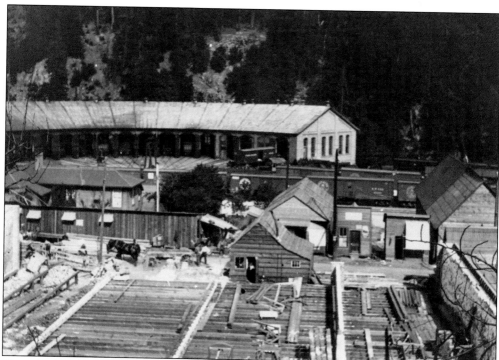

The rebuilding of Sacramento Avenue businesses took place rapidly after the fire. The row of buildings under construction on the west side of the street, facing the railroad yard, is seen here from the hillside behind. These buildings would soon open as the Eagle Barbershop, Red Cross Drugstore, Castle Rock Saloon, and F. M. Walker's Men's Furnishings. Looking south on Sacramento Avenue (below), a sign indicates temporary quarters of Levy's mercantile and the Red Cross Drugstore on the east side of the street. Another indicates the Eagle Barbershop in one of the temporary wood frame buildings that were quickly built following the fire in the middle of what is now Sacramento Avenue. Construction of permanent masonry buildings proceeds on the west side of the street. (Above, Dunsmuir Chamber of Commerce; below, © Masson-Gomez family.)

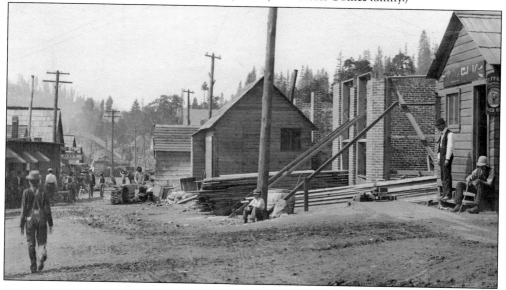

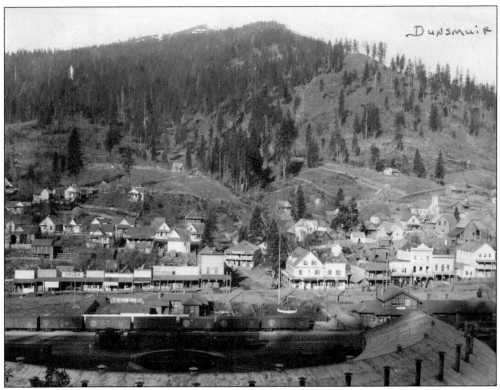

Morning sunshine lights up Sacramento Avenue prior to the fire (above). The hillsides to the west show the effects of logging. The Catholic church, dedicated in 1894, is visible in its original form. The same view around 1910 (below) shows the rebuilt town, with the Weed Hotel, new buildings lining Sacramento Avenue, and the attractively developed depot area. (Above, Ron McCloud; below, © Dave Maffei.)

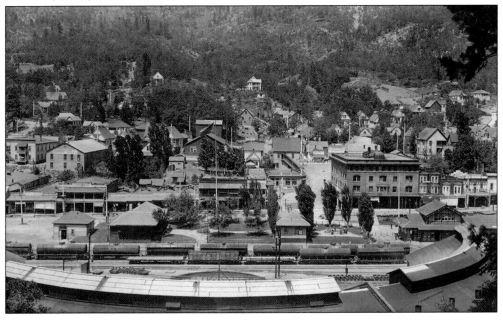

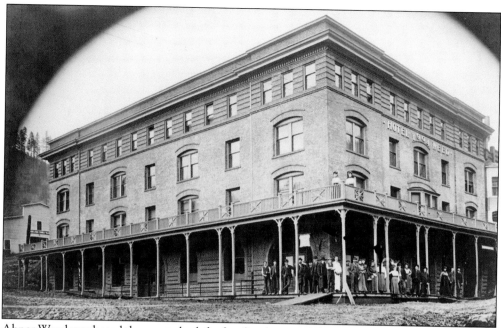

Abner Weed purchased the empty lot left after fire destroyed the Mount Shasta Hotel and within a year had built the four-story Weed Hotel—the tallest building in Siskiyou County. Designed by architect Ralph Warner Hart and advertised as the "finest hotel in Northern California," it contained 102 lodging rooms. Its elevator was the first in Siskiyou County. The elegant Weed Hotel was popular with train passengers including celebrities and presidential parties. Both locals and travelers patronized the restaurant, bar, and shops on the ground floor. Abner Weed (1842–1917) was a Civil War veteran and was present with Ulysses S. Grant at Robert E. Lee's surrender. He was very successful in the lumber business and founded the lumber town of Weed, 18 miles north of Dunsmuir. He was a county supervisor (1900–1908) and a state senator (1906–1910). (Above, Siskiyou County Museum; below, Alan Moder.)

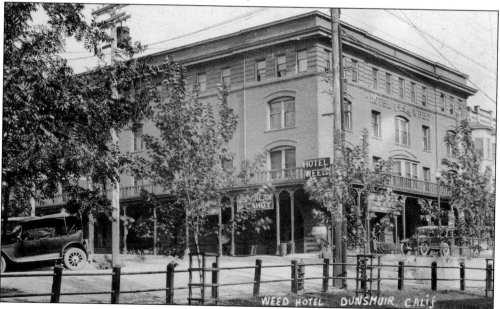

These c. 1917 summer afternoon views feature what is a major intersection in the business district today. Looking north on Florence Avenue (above), Pine Street drops downhill to the right, just past the post office (now Premier West Bank). The bell tower of the Methodist Episcopal Church is visible above the trees on the left. It burned in the 1924 fire, along with the homes on that side of the street. After he had taken the above photograph, the photographer then turned and pointed his camera to the south (below). Cedar Street drops to the left. Florence Avenue is unpaved and lined with private residences. A lady at the top of the hill can be seen spraying water, perhaps on her flowers, or on the street to settle the dust. (Ron McCloud.)

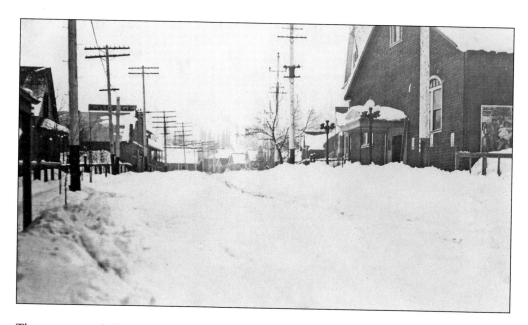

The community hall, theater, and movie house on the west side of Florence Avenue was known as the auditorium. It was destroyed by fire in 1921, and three years later, the southern addition to the Travelers Hotel was built on the site. This winter scene (above) looking south was photographed in 1915. A movie poster on the side of the building advertises the 1914 movie *The Spoilers*, starring William Farnum. The Travelers Hotel building (below) appears with only the northern half complete. A poster in the window of the post office building across Florence Avenue to the east advertises a performance of *Uncle Tom's Cabin* on Wednesday, April 27, 1921. The White House Grocerateria occupies the ground floor of the hotel displaying its wares along Pine Street. (Above, © Dave Maffei; below, Ron McCloud.)

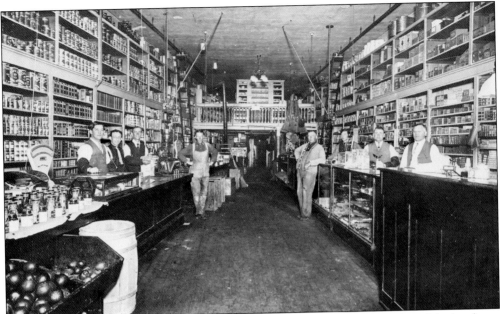

Jacob Eherenman (second from the right) and his partner, Frank Tetreau, purchased the hardware and grocery portion of Alexander Levy's mercantile in 1908. Levy retained the dry goods and clothing portion. The Sacramento Avenue business appears to have been well stocked with apples, brooms, tea, and other items too numerous to list. Rolling ladders provided access to stock on upper shelves. (Siskiyou County Museum.)

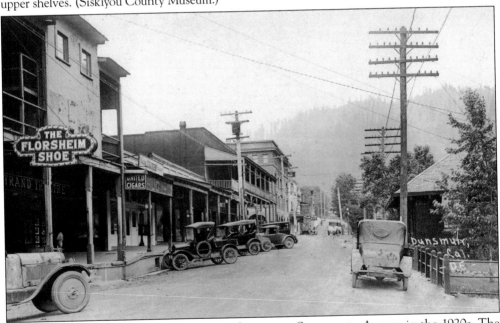

The automobile began to make its presence known on Sacramento Avenue in the 1920s. The Wagoner Building on the left had Wagoner and McCarville Men's Clothing (which sold Florsheim shoes) and the Castle Rock Saloon on the ground floor. On the second floor were hotel rooms and the Strand Theater, which was famous for its pipe organ. The movie playing was *The White Moth* starring Barbara LaMarr, released in 1924. (Alan Moder.)

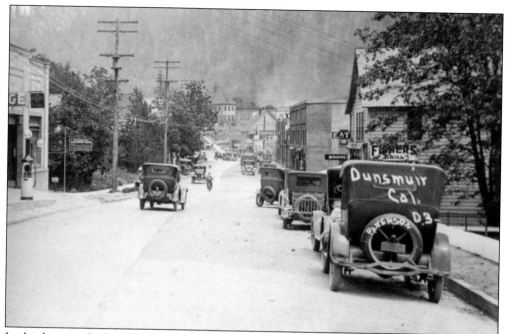

In the distance, looking north on Florence Avenue is the Dunsmuir Elementary School building with its prominent bell tower. The two-story building on the right is Fishers Restaurant and rooming house. In 1967, the fire hall was built on this lot to expand the facilities of the city hall and fire station. (Ron McCloud.)

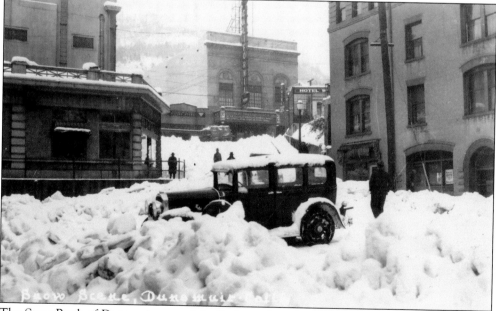

The State Bank of Dunsmuir was originally located in the building on the south side of Pine Street. Visible up the hill on Florence Avenue is the Sprouse Reitz 5¢-10¢-15¢ store and the California Theater. The movie playing is *My Sin*—starring Tallulah Bankhead and Frederick March—released in 1931. A sign in the window of the store in the Weed Hotel building advertises suits for $22. (Alan Moder.)

Whenever talk of the weather turns to remembering the big storms, a common story is "the year the snow was so deep that tunnels had to be dug to reach the stores." It actually happened a number of times. Installation of concrete sidewalks was approved by the city council in 1921. In this photograph, taken in front of the 1925 Eachus building on the west side of Florence Avenue, the boardwalk is visible in front of the I.X.L Store. The sidewalk project apparently took a few years. (Donna Howell.)

A winter storm does not appear to interfere with the work of the telephone company. The official Pacific Telephone Company car is a 1934 Ford Coupe. With tire chains on and parked in front of the company office on the ground floor of the Travelers Hotel on Pine Street, it is ready for business. Today this model with its "suicide" doors is very desirable to collectors. (Donna Howell.)

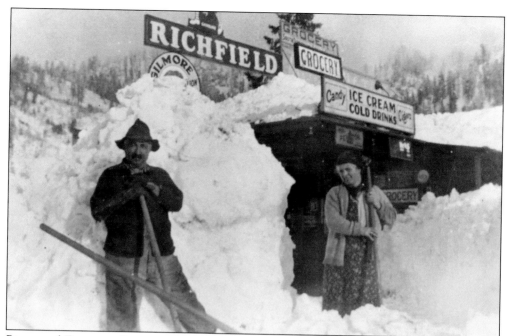

Pietro and Francesca Rosetti emigrated from northern Italy. In 1927, they opened the South Highway Grocery. The original building sits on Dunsmuir Avenue and is a private residence today. Their descendents, the Manfredis, continue to operate a service station and convenience store approximately a half mile to the south, where a fifth generation prepares to continue the family business. (Manfredi family.)

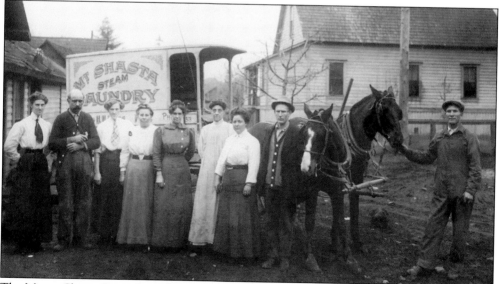

The Mount Shasta Steam Laundry was located on Wiley Avenue, a street that no longer exists. Along with Frisbie Avenue, Bertha Avenue, and Villa Avenue, it vanished with the arrival of the central Dunsmuir Interstate 5 northbound on-ramp and Florence Loop. The laundry operated at that location for 10 years before merging with the Dunsmuir Steam Laundry, located on Butterfly Avenue in 1920. Horse-drawn pick up and delivery service would have been appreciated in the days before washing machines. (Siskiyou County Museum.)

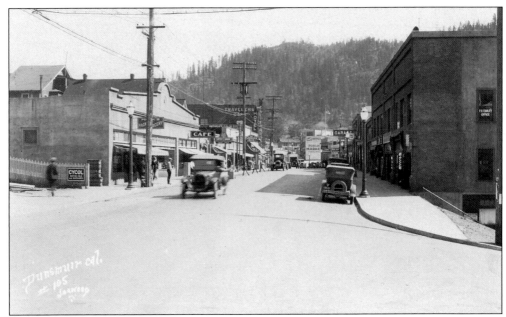

The Malone Building on the left side of Florence Avenue, across from the Mossbrae Apartments, was completed in 1925 and consisted of three store fronts. Meek's Grocery Store occupied the southernmost. It later became Wheeler's Liquor and Sporting Goods, followed by the Garden Court Florist (Grace Renoud and Marjorie Young), and a succession of restaurants to the present. (Alan Moder.)

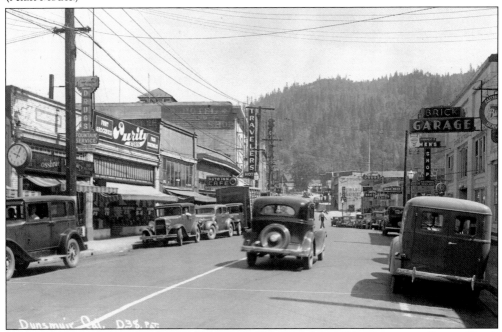

It is 10:05 a.m. according to the clock in front of Huddle's Jewelry Store, next to Beanie King's Mossbrae Pharmacy, which was established in 1927, and Pon's Purity Grocery Store. These commercial buildings replaced wood frame residential structures, which once lined Florence Avenue. (Alan Moder.)

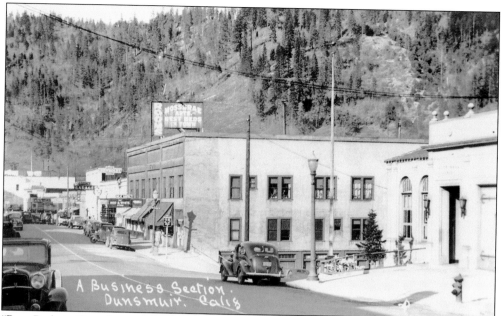

"Best Beds in Town" is proclaimed by the Mossbrae Apartments around 1940. Built by early developer Frank Van Fossen after the 1903 fire destroyed a Chinese laundry at this location, it had 24 apartments upstairs and retail shops on its ground floor. Storefronts on the Cedar Street side were later converted to apartments. The Mossbrae was destroyed by fire in 1989. Heavily logged hillsides are notable in this photograph. (Alan Moder.)

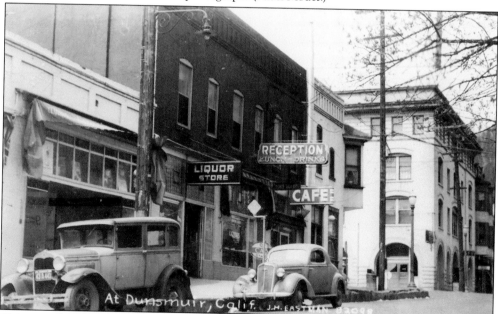

This row of buildings constructed after the fire of 1903 was destroyed by another fire in 1965. The S. P. Neher building (center) housed the Original Package Store (liquor store) and the Reception Billiards and Saloon. The Gongwer Building to the right housed the Palm Café (Frank Talmadge, proprietor). Both buildings had hotel rooms on their second floors. The Weed Hotel on the far right did not burn in the 1965 fire. (Alan Moder.)

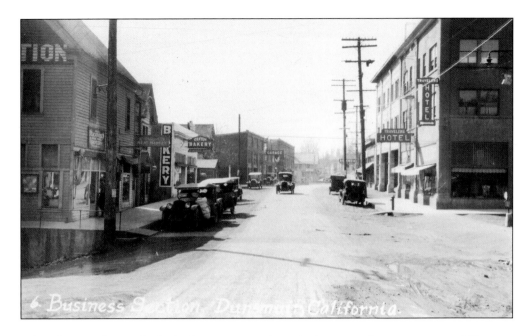

After the 1924 fire, with the highway passing through the town, the intersection of Florence Avenue and Pine Street became the hub of Dunsmuir's business district. The Brick Garage building was completed in 1916. The Canyon Bakery moved to this location in 1924, and the three-story Travelers Hotel building was completed in 1924. In 1927, the State Bank of Dunsmuir moved from Pine Street into its new building on Florence Avenue and became a landmark. Visible below are the Toggery clothing store, Bascoms Meat Market, the Brick Garage, the Travelers Hotel and Café, and the White House Department Store displaying fashionable ladies dresses in its Pine Street window. (Alan Moder.)

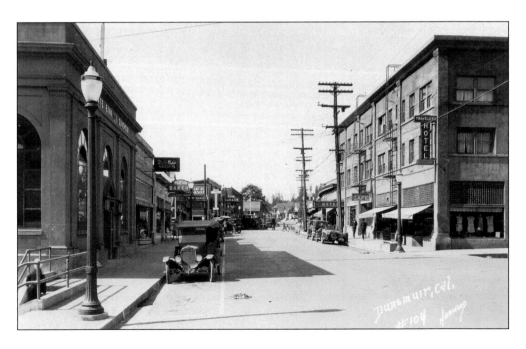

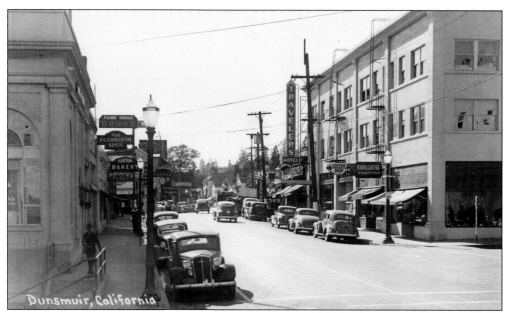

By the early 1950s, the intersection of Florence Avenue and Pine Street was busy indeed. U.S. Highway 99 traffic flowed through the town and the post World War II boom economy brought increased business and commerce. The California Theater/Masonic Temple, completed in 1926, was designed by San Francisco architect Carl Werner. It was built on the site of a large wood frame building, which was originally a livery stable, and later The Cleanatorium Laundry, Cethel Jones's Rexall pharmacy, and Sprouse Reitz department store were just to the south of the theatre. Beyond it to the north was the California-Oregon Power Company. Movies playing were *The Magic Bullet*, a 1940 Academy Award nominee starring Edward G. Robinson and Ruth Gordon, and *Parole Fixer*, a 1939 cops and robbers movie starring William Henry and Virginia Dale. (Alan Moder.)

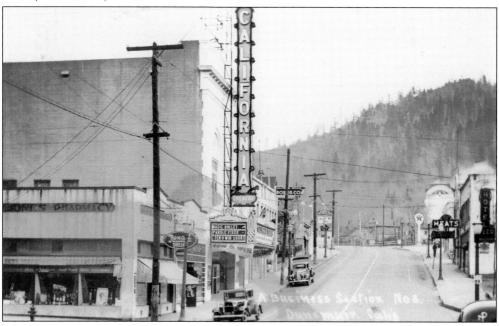

The "new" elementary school visible to the north replaced the original 1891 two-story wood frame school building that burned in 1925. The Standard Service Station on the right is in the 900 block of Florence Avenue, which became the 5900 block when the name was changed to Dunsmuir Avenue in 1961. (Siskiyou County Museum.)

The State Bank of Dunsmuir was established in 1904, operating in offices in the Weed Hotel. It moved to the south side of Pine Street, east of the present bank building, in 1927, when it became the Security State Bank Company and then became the Bank of America in 1931. In this early photograph, DeWitt's Style Shop occupies a portion of the building. (Dunsmuir Chamber of Commerce.)

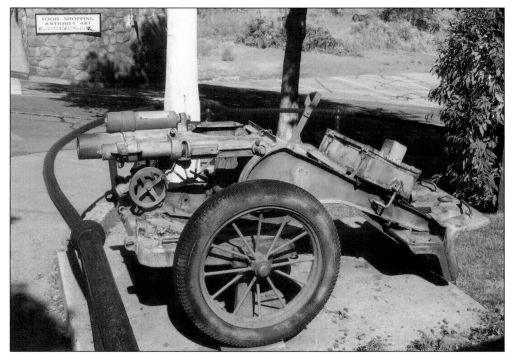

The origin of the World War I cannon displayed in front of the justice court building is uncertain. The German 77mm artillery piece was probably shown on the 1919 Victory Loan Train, which was made up in Dunsmuir. It toured the western states displaying war trophies and promoting Victory Loans (war bonds). The justice court building was completed in 1925, and the cannon was placed on its special concrete pad. (Deb Harton.)

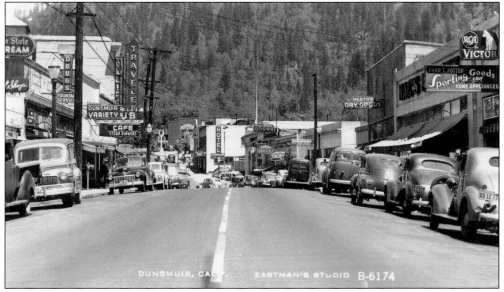

By the early 1950s, businesses lining Florence Avenue included Dunsmuir Variety, Paddy's Place, Heath's Dry Goods, Mac's Market, and Fred Potter's Sporting Goods. U.S. Highway 99 still carried traffic through the business district, and the years following World War II were prosperous times. (Alan Moder.)

The Joyland complex was developed by Frank Talmadge who, in 1928, leased City Park (not including the ballpark) from the City of Dunsmuir, and purchased Shirley Auto Camp (below). Joyland then extended from City Park south to the Dunsmuir Bridge. Talmadge installed the swimming pool, put in picnic tables, a playground, and built the Corral Resort bar, restaurant, and dance hall. A miniature golf course, outdoor dance floor, and roller-skating rink were also featured. Joyland closed after about 10 years, although the pool reopened in 1947. The Corral continued operating into the 1950s and was taken out when the Siskiyou Avenue overpass was built over Interstate 5. The swimming pool and the Shirley Camp office building still exist. (Alan Moder.)

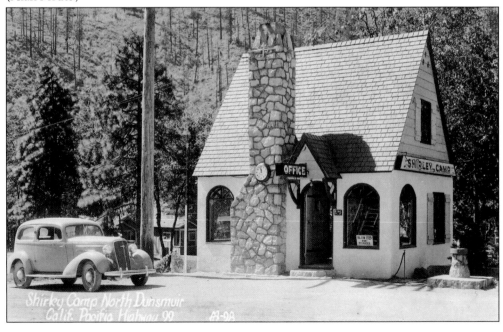

The Dunsmuir Meat Market and Warner's Grocery, later Bascom's Market, immediately north of the Van Fossen home on the east side of Florence Avenue, was developed by Maude Rochford, a heavy investor in Dunsmuir real estate from the early 1900s. The interior of Warner's Grocery has a large weighing scale, which is still in daily use at the Dunsmuir Hardware Store. Warner's Grocery featured well-stocked canned goods shelves, attractive display counter, brass cash register, and a padlocked penny candy gumball machine. (Ron McCloud.)

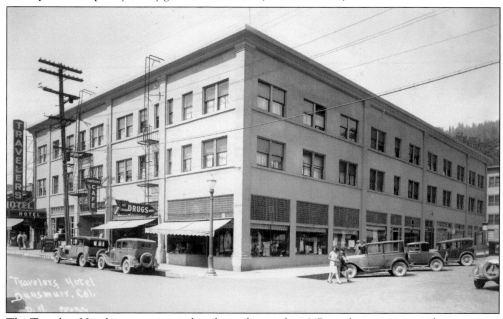

The Travelers Hotel was constructed in three phases; the 1917 northern portion with two stories, addition of a third story in 1919, and the adjoining southern half in 1924. In addition to lodging, in the early days it housed the business establishments of Dr. E. J. Cornish; Dr. George Malone, dentist; Gustav Hutaff, druggist; Hutaff and Carlquist, jewelers; California-Oregon Power Company; Pacific Telephone Company; and the White House Groceratteria. (Alan Moder.)

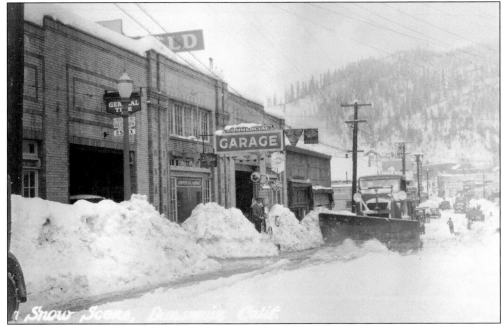

The Commercial Garage advertised service for Hudson, Essex, and Nash automobiles. It was located directly to the south of the present Dunsmuir City Hall building visible in this photograph—which was then occupied by Young's Furniture Store. The Commercial Garage collapsed under the weight of a snowstorm in 1966, was never rebuilt, and became a municipal parking lot. (Alan Moder.)

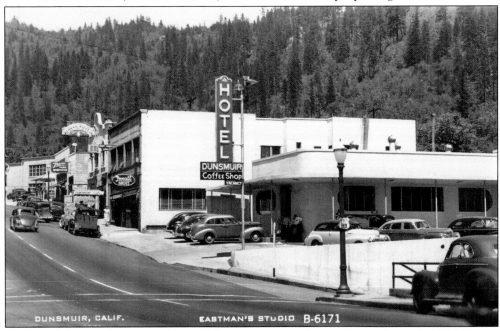

Fire gutted the Weed Hotel in 1944, and the interior was refurbished by architect L. H. Nishkian, pioneer earthquake design engineer. At the same time, he designed the addition facing Florence Avenue, which was completed in 1947. Because of the steep terrain, the new addition joined the Weed Hotel at its fourth floor, resulting in the famed "upside down elevator." (Alan Moder.)

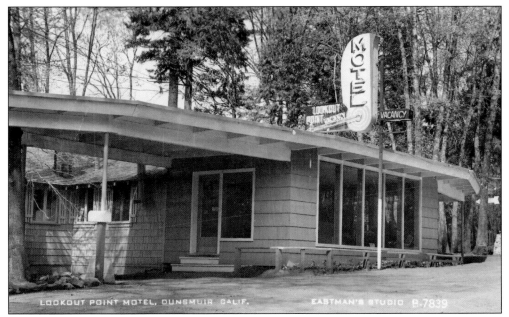

The Lookout Point Motel in north Dunsmuir was operated by legendary fly fisherman Ted Fay (below). The motel became a mecca for fly fishermen and women from far and wide as Ted Fay's fame as a fly tier, fishing guide, and fishing promoter grew to worldwide status. He used weighted flies such as the burlap and the black bomber, invented in the 1920s by Ted Towendolly, to develop a system of fly fishing called the short line weighted fly method. Fay operated his fly shop business in the Lookout Motel from 1948 until the late 1950s when it was purchased by the state, as it was in the path of the arrival of Interstate Highway 5. He then moved his fly business into his home until his death in 1983. (Above, Alan Moder; below, Dunsmuir Chamber of Commerce.)

In 1923, north of Lookout Point, pairs of silver foxes arrived at the U.S. Fox Farm's 43-acre site near Shasta Springs. The president of the company assured the public that the foxes would not be raised for pelts and would be sold as breeding pairs for $2,000 or more. Over 50 men were employed in preparation of 100 pens. When the business went bankrupt in 1928, it was rumored that the foxes were released and that they interbred with the native species. To this day, many claim to glimpse silver foxes running wild in the area. (Alan Moder.)

A Roosevelt Strain Silver Fox
U S SILVER FOX FARMS SHASTA SPRINGS CAL

Eight

PEOPLE AND PLACES

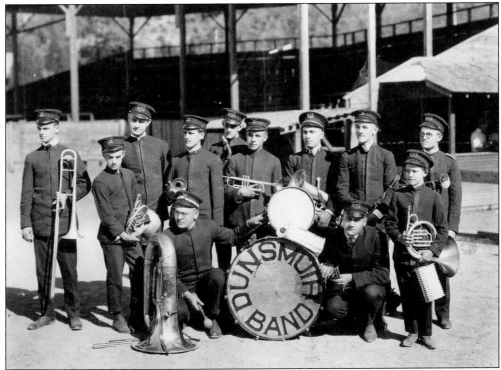

Dunsmuir residents are involved people. Throughout the town's history, they have been involved in its progress, pastimes, and politics. Business people, railroad employees, professionals, and retirees have helped to build the town by being involved in its schools, churches, and service organizations. This well-uniformed 12-piece marching band is a good example. While the names of the musicians have been lost, their confident poses and shiny instruments make them a proud group. There appears to be a wide spread in the ages of the musicians. Some were probably students, and others were working people. They have been part of the dedication ceremony for the ballpark grandstand behind them. It was built in 1921 and was where the legendary Babe Ruth played an exhibition game in 1924. Baseball was taken very seriously in that era, with rivalries between the towns and championships contested to exciting conclusions. (Ron McCloud.)

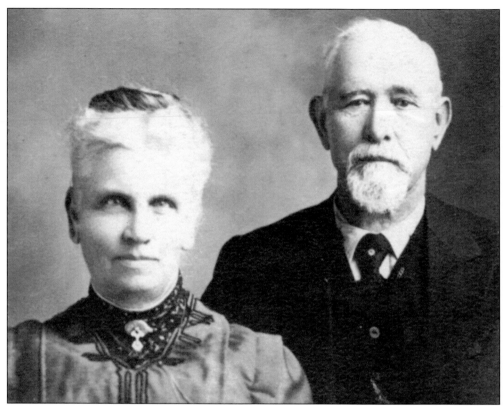

William J. Branstetter (1835–1926), pictured above with his wife, Susan Ann, came to Dunsmuir from Roseville in 1886 and was truly one of the town's founding fathers. He opened the first general merchandise store on Sacramento Avenue, the Branstetter Lodge Hall / Opera House, and was one of Dunsmuir's largest property owners and real estate developers. He was a city councilman, school trustee, charter member of the Dunsmuir Masonic Lodge, justice of the peace, and member of the first fire department. The Branstetter family home was on Branstetter Street near Rose Avenue (below). The 1903 fire destroyed a great deal of Branstetter's properties, but he stayed, rebuilt, and spent the rest of his life in Dunsmuir. (Ralph Menges and Evonne Moffett.)

Although far from fashionable cities, Dunsmuir's ladies were style conscious. In 1897, a photographer captured William Branstetter's daughter, Florence Maude (right), in a pose that belied the fact that she was from a mountain railroad town. Her gown, hairstyle, and her pose with a unique three-legged chair would have fit in San Francisco or Sacramento. Dunsmuir's Florence Avenue was named for her. Social life in Dunsmuir was active, and the women who belonged to the whist-playing "500 Club" (below) represented a cross-section of the town's business and civic leaders. From the left are Mildred Davidson, Vi Williams, Bessie Clarke, May Coggins, Maude Hawkins, Edna Hamilton, Josephine Huff, Thunselda Ward, Martha McDaniel, Sue Cornish, Lottie Malone, and Hattie Standley. Whist was a widely popular card game at the time until it was replaced by bridge, which is very similar. (Ron McCloud.)

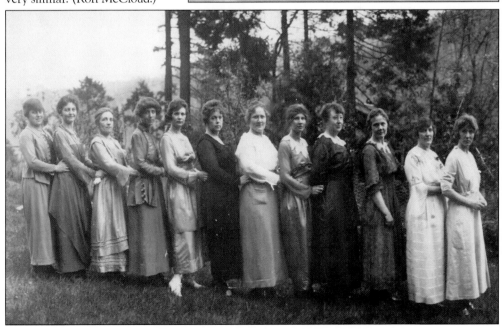

Pictured is possibly the first funeral in the Dunsmuir cemetery. William Branstetter, who was a charter member of the Dunsmuir International Order of Odd Fellows, donated land for the cemetery to the I.O.O.F. around 1890, and the Odd Fellows later deeded the property to the City of Dunsmuir. Records indicate that the oldest grave in the cemetery is that of infant Martin Murphy who died in February 1890. (Siskiyou County Museum.)

The Dunsmuir Volunteer Fire Company was founded in 1897. Firemen were prepared when the worst fire in the town's history struck in 1903, and they have been prepared for disasters ever since. Their first motorized fire engine, towing a hose cart, is shown here at the intersection of Florence and Oak Streets in 1918. (Ron McCloud.)

Early parades on Sacramento Avenue were festive and colorful. Ladies turned out in their finest gowns, hats, and parasols to see the decorated horses and lively entries. Balconies on the building fronts were a common feature and parade spectators found them to be good viewing places. The Weed Hotel balcony was decorated with bunting for this parade as were the other buildings erected after the 1903 fire. In the coming years as the boardwalk was replaced with concrete walkways, balconies on the building fronts were taken down. (Above, Ron McCloud; below, Dunsmuir Chamber of Commerce.)

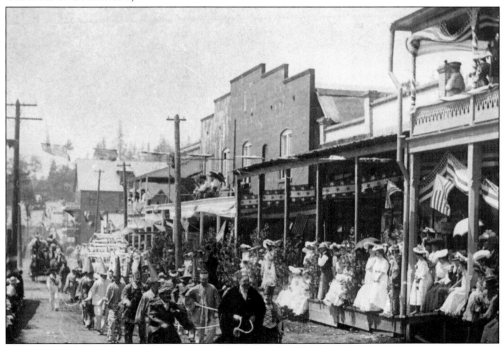

Independence Day was an important event, with parades and festivities hosted by a different Siskiyou County city each year. These gentlemen formed the executive committee for the 1913 celebration and posed at the entrance of the Weed Hotel to promote their efforts. From the left are E. H. Allen, treasurer; C. O. Clark, chairman; R. F. Crist; S. J. Wilkins; F. Talmadge; S. A. Gilson; and R. O. Gwyn, secretary. (Siskiyou County Museum.)

Grace Pickthorn (Renoud) was a noted railroad crew dispatcher and later a businesswoman in Dunsmuir. Following her career with the railroad, she owned the Garden Court Flower and Gift Shop, a prominent Dunsmuir business. (John Signor.)

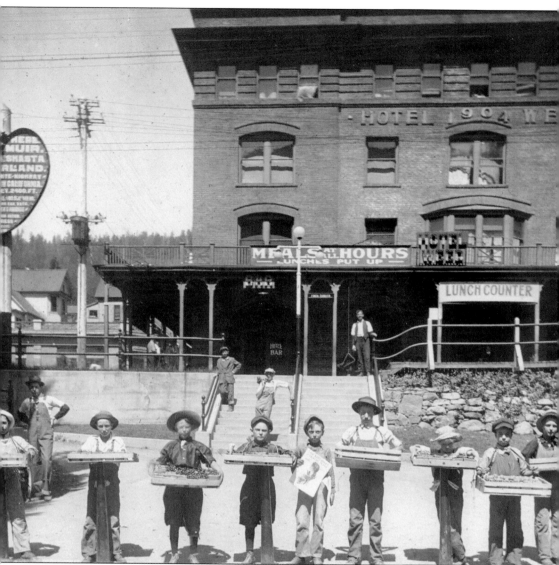

When train travelers arrived in Dunsmuir, they were met by boys peddling apples, cherries, and even reading materials—the boy in the center holds a *Saturday Evening Post* dated June 19, 1915. The Weed Hotel lunch counter competed with other restaurants on the street for customers, with the sound of a triangle chime. The heart shaped sign read, in part, "Heart of the Shasta Wonderland" and "Healthiest spot in California." (Ron McCloud.)

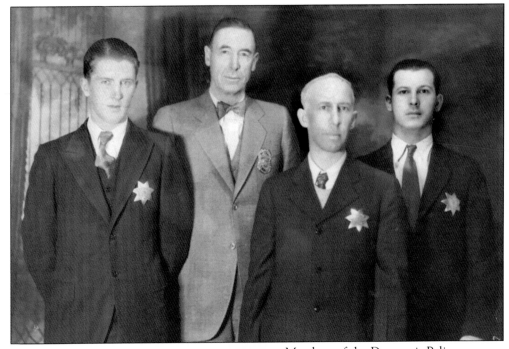

Members of the Dunsmuir Police Department (1933) display their badges. They are identified as, from left to right, Jack B. Leahy, Chief Tom Wright, Clyde Norman, and Carlos Silva. The police department offices were in the basement of the city hall/justice court building and included an on-site jail. (Ron McCloud.)

In a 1935 event that shocked the normally peaceful and gentle Dunsmuir, Jack Daw, the popular police chief, was fatally shot while assisting CHP officer Cyril Malone in locating two men suspected of a robbery in nearby Castella. The robbers opened fire and an injured Malone drove to the inspection station nearby to sound a fire alarm for assistance. One of the suspects, Clyde L. Johnson, was arrested. He was housed in the Siskiyou County jail and was later hanged—one of the last lynchings on record in the state of California. The second suspect was apprehended 13 months later and received a life sentence for his role in the murder of a family man. (Deb Harton.)

The Southern Pacific Railroad provided housing for local officials along the east side of Sacramento Avenue, facing the railroad yard. The assistant superintendent's home was across Sacramento Avenue from the Knights of Pythias Hall, where the infamous 1924 fire began, destroying it and buildings on the west side of Sacramento Avenue. It then spread to the west where it burned a number of buildings on Florence Avenue. (John Signor.)

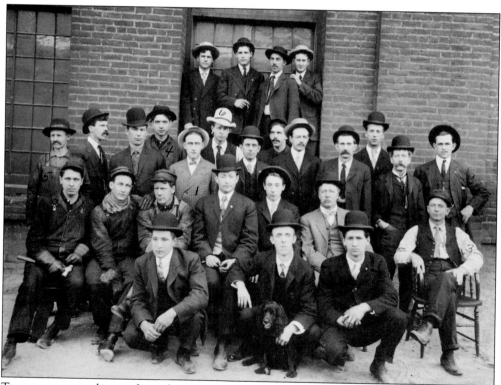

Twenty-seven mechanics from the Southern Pacific shops posed for this formal photograph in 1908. While most of them dressed up for the occasion, a few seated on the left appear to have just stepped off the job, still holding their tools. The roundhouse foreman, Charlie Bess, is seated on the chair on the right side. (Siskiyou County Museum.)

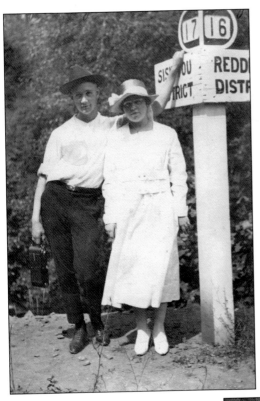

Marvin Seng, a 23-year-old family man and fireman from Dunsmuir, was shot down in cold blood by the D'Autremont brothers just south of Ashland, Oregon, at tunnel 13. The D'Autremonts, led by 19-year old Hugh and backed up by 23-year-old twins Ray and Roy, held up the westbound train that was rumored to be carrying $90,000. In October 1923, they stopped the train, blew up the mail car (as well as the mail clerk), shot three people, including Dunsmuir engineer S. L. Bates, but seemingly got spooked and ran before entering the destroyed mail car. The *Dunsmuir News* reported that almost 500 men participated in the ensuing manhunt that included bloodhounds and a patrol plane sent up from San Quentin prison. All three eventually served prison time. (Left, Ralph Menges and Evonne Moffett; below, Deb Harton.)

Avalanches, snowfall, and mudslides were considered more newsworthy than the high water that continues to occur frequently. When snowfall was heavy in the spring, it was almost guaranteed, and Dunsmuir took it all in stride. Flooding was recorded in 1890, 1937, 1938, 1956, 1974, 1995, 1997, 2000, 2003, and 2006. Entire houses floated away in 1937. The railroad still contends with storm damage on almost an annual basis. Pictured above, damage to the roundhouse occurred in 1956. Below looking west from the east side of the Scherrer Avenue Bridge in 1974, it is easy to understand how entire properties were again washed away. During recent flooding, one resident remarked that the water in the Sacramento River rose so quickly that the creek near his property seemed to flow backward and uphill. Dunsmuir has always weathered tragedy with dogged resiliance and grace. (Above, Shasta Division Archives; below, Paul Carter.)

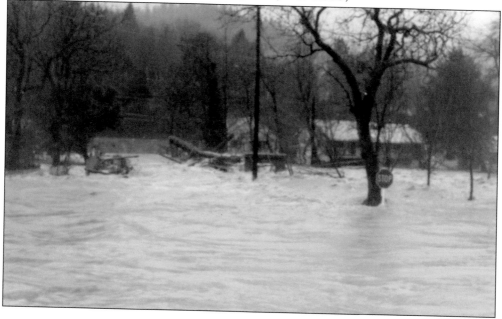

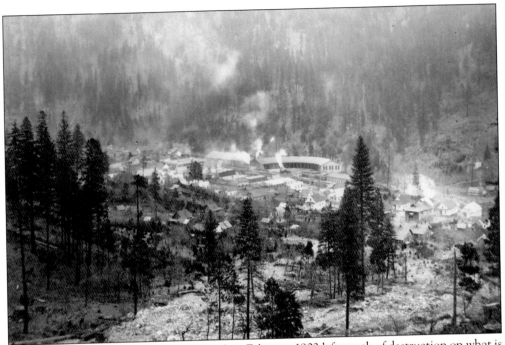

The landslide that swept down Alder Creek in February 1902 left a path of destruction on what is now Oak Street. Heavy, continuous rain had softened the hillside to the west, which shifted and formed a dam that filled and burst suddenly. The resulting flow—reportedly 20 feet high—swept across town carrying boulders, tree trunks, and debris until it reached the Sacramento River. (John Signor.)

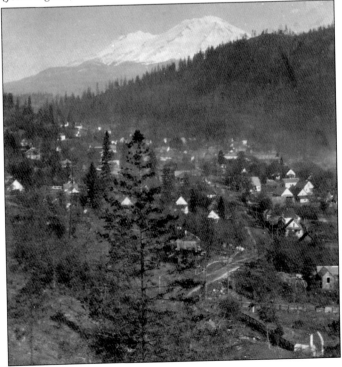

The white archway in the lower right of this photograph is the entrance to the Dunsmuir Cemetery around 1910. It sits on land that was donated to the International Order of Odd Fellows by William Branstetter and later was deeded to the City of Dunsmuir. Florence Avenue—which would become Highway 99 and later Dunsmuir Avenue—curves right and then left toward the center of the town with snowcapped Mount Shasta in the distance. (John Signor.)

Herman Scherrer (1844–1936), a Swiss immigrant, settled in Dunsmuir in 1888. He built and operated the first electric plant to serve the town. A wing dam on the west side of the river (right) at what is now Scherrer Avenue sent water through a 200-yard-long diversion canal to spin wheels on a generating dynamo located at the building in the lower right (below). Completed in 1893, the plant supplied only enough electricity for 250 light bulbs when it first started operating. By 1905, there were almost 200 customers and the company incorporated as the Scherrer Light and Power Company. In 1908, it was sold to the California Oregon Power Company, which ran the plant until the 1920s. In the picture below, the Dunsmuir Cemetery can also be seen. (John Signor.)

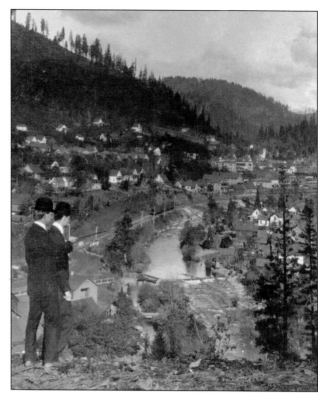

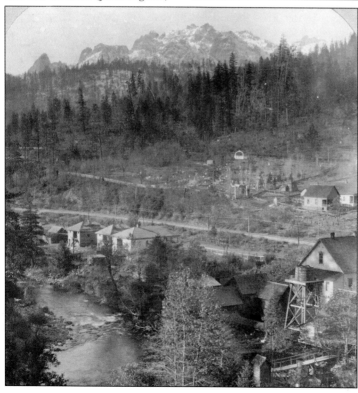

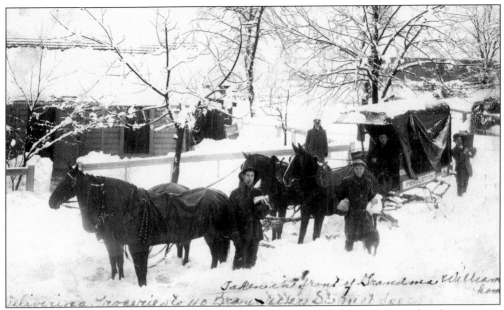

Takscin front of Grandma William... delivering Groceries to 110 Bran... etter St... mill doc

Snow never seems to present a great obstacle in Dunsmuir. Life goes on. A four-horsepower sled was all that was needed to deliver groceries on Branstetter Street (above) in spite of what appears to be over a foot of snow. Major snowstorms such as the one in 1890 might have been more problematic, with snow more than 12 feet deep. Horses used to pull delivery wagons for Eherenman's Mercantile (below) were kept in a stable on Spruce Street. Jake Eherenman on the right has his horse saddled for riding, perhaps with his nephew James Lockhart, the little boy to his right. In this *c.* 1920 scene, the original Catholic church is in the background. It burned in 1932 and was rebuilt on the same site. (Above, Ralph Menges and Evonne Moffett; below, Ron McCloud.)

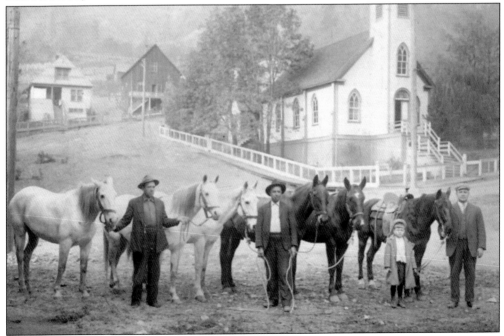

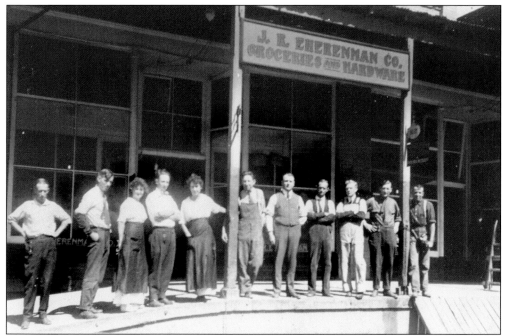

Employees of J. R. Eherenman's Mercantile pose on a sunny day in 1915 or 1916. Some 70 years later, Harvey Ahl was able to identify some of them. From left to right are unidentified, unidentified, Esther Greenman, Chester Lipp, unidentified, Harvey Ahl, Jake Eherenman, Charles Selby, Matt Hume, unidentified, and unidentified. (Ron McCloud.)

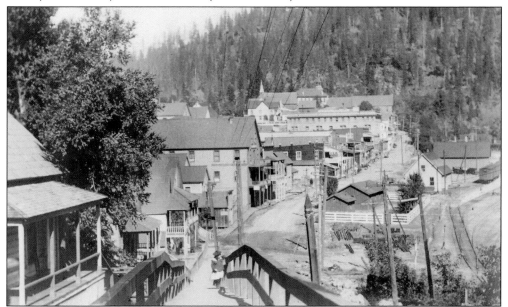

The boardwalk uphill, toward the south on Sacramento Avenue, gave access to homes on that street and also provided a spectacular view of the railroad yard, the Sacramento River, busy Sacramento Avenue, and the tree-covered hills. Visible in this photograph—taken after 1903—are the bell towers of the Methodist Episcopal church and Dunsmuir Elementary School, the large double balconied Birmingham Hotel, and the fenced railroad section house. (© Masson-Gomez family.)

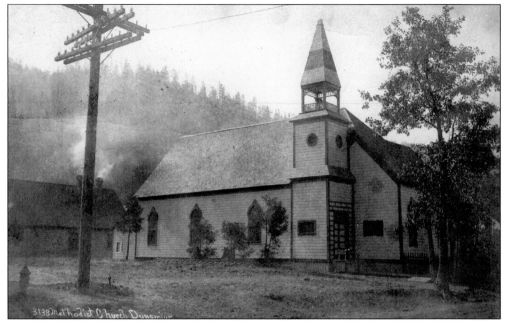

The Methodist Episcopal church, completed in 1889 at the corner of Florence and Spruce Streets, was the first church in Dunsmuir. In 1921, it was moved slightly to make room for a new church and then was converted to a gymnasium and library. Both burned in the 1924 fire. Property on Oak Street was purchased in 1928, and a new church was completed in 1929, but it collapsed under snow load in January 1966. (Alan Moder.)

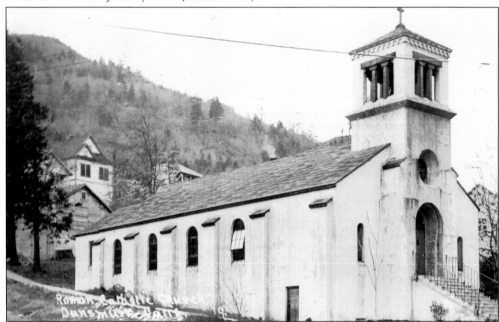

Prior to the completion of The Church of the Sacred Heart in 1894, mass was celebrated in various public halls. The church burned in 1932 but was rebuilt in the same spot using a similar design. The new church was dedicated as St. John's. An arson fire in 1975 damaged the church. It was saved and survives in this form today. (Alan Moder.)

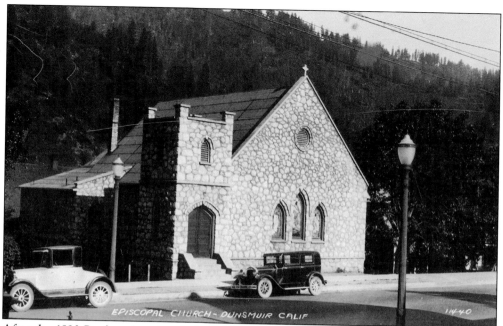

After the 1890 Presbyterian church, located on Spruce Street at Florence Avenue, was sold to the Episcopalians in 1897, it burned in the 1924 fire. The Episcopalians then purchased property to the south on Florence Avenue and built the "Stone Church" in 1925. It was sold to the First Baptist Church in 1969. (© Dave Maffei.)

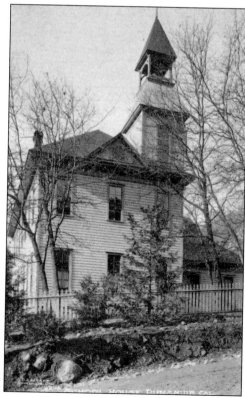

The Dunsmuir Elementary School District was established on July 8, 1887, and the first classes were held in houses at 319 and 615 Florence Avenue. Enrollment was up to 79 when the first elementary schoolhouse was dedicated on September 25, 1891. The two-story frame building located between Florence Avenue and Sacramento Avenue measured 64 feet by 32 feet and had a 12-foot-by-12-foot bell tower 26 feet high. There were two classrooms on the bottom floor, each with a stove. A library and laboratory were on the second floor. (Alan Moder.)

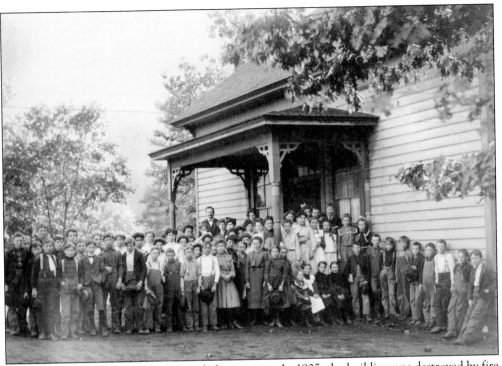

Students and teachers pose at the north facing entry. In 1925, the building was destroyed by fire and the new grammar school was erected on almost the same spot. (Siskiyou County Museum.)

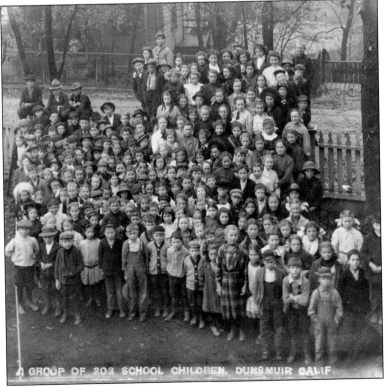

A GROUP OF 203 SCHOOL CHILDREN. DUNSMUIR CALIF

Captioned "A group of 203 school children," this photograph was probably taken around 1900 near the picket fence, which was on the east (Florence Avenue) and west (Sacramento Avenue) sides of the school grounds. Enrollment went from 79 in 1890 to almost 700 in 1955, to about 450 in 1968. (John Signor.)

A new two-story grammar school opened in the fall of 1925. A six-classroom building was added south of the main structure and a two-room building was added to the north in 1928. In 1948, another building was added to the south with four classrooms, a library, and an auditorium that survives to the present. In the fall of 1968, classes were moved to the present location in north Dunsmuir. (Alan Moder.)

Dunsmuir had no high school until 1911 when 26 students attended classes in a vacant room in the elementary school. Until a permanent high school building could be built, this duplex on Florence Avenue was rented. J. W. Palmer was principal, and there was an active Mothers Club involved in selecting a site. Construction began after a bond issue was passed in February 1920. (Ron McCloud.)

The new high school cornerstone was laid on May 16, 1920. The auditorium was the first part of the complex to be completed, in 1922. Earth slides plagued the site. Drains and retaining walls were installed, but it continued to be a problem. Consolidation with Castella and Sweetbrier into the Dunsmuir Joint Union High School District in 1927 added revenue for needed improvements and expansion. (Siskiyou County Museum.)

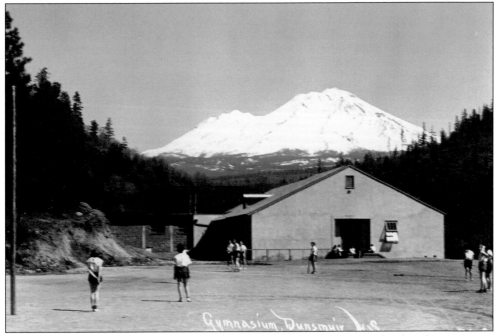

Several proposals to move the high school to a different location never developed. A six-room addition connected by a corridor was built in 1928 and ten years later, a new gymnasium was added. By the late 1960s, the need for a new structure was evident. The gymnasium was saved and a new two-story building to the south was completed in early 1974. (Alan Moder.)

By the 1920s, the residential district to the south of town had developed. From across the river, the view to the west, looking up Branstetter Street (above), includes much of what was originally William Branstetter's property. Structures in the foreground are on Butterfly Avenue, with the river and the railroad tracks behind them. Beyond the river, a surprising number of homes have survived from the late 1920s to the present. Butterfly Avenue is just beyond the row of houses in the foreground (below) and from Woodin Avenue, the row of homes on Sacramento Avenue can be seen across the river. A sign on the balcony of the large house in the center says Craig View Apartments. (John Signor.)

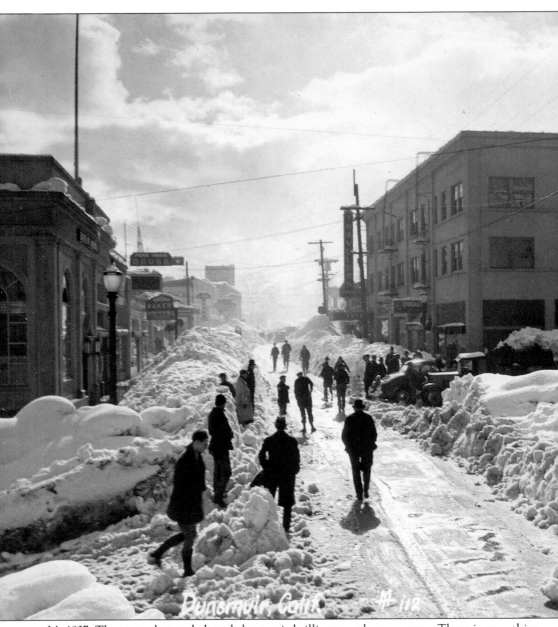

It's 1937. The storm has ended, and the sun is brilliant on the new snow. There is something that draws people out and into the light, moving with optimism and the sure knowledge that the worst is over. It is a scene often repeated in Dunsmuir and perhaps symbolic of the way the town has dealt with its trials and tribulations over the years. Numerous and horrific fires, avalanches, storms, floods, chemical spills, and economic downturns have been challenges that the people of Dunsmuir have met with optimism. The town is a survivor. In her book, *Ties and Tales*, Reva Coon said, "Pause a while and look back over the last one hundred years and be impressed by what has been accomplished in this little mountain railroad town. Despite monumental set backs, it has not lost its optimism." The stories and images from the past are the historic foundation that the town is built on. They give the strength to step forward with the optimism so characteristic of Dunsmuir. (Kaye Hall, daughter of Ivan Tucker of Martin and Tucker Photographic Studios.)

Bibliography

Coon, Reva and Grace M. Harris, Eds. *Dunsmuir Centennial Book 1886–1986*. Dunsmuir, CA: The Dunsmuir Centennial Committee, 1985.

Cutting, Steven, *A Slice of History*. Dunsmuir, CA: 1997.

Johnstone, E. McD. *Shasta—The Keystone of California Scenery*. Buffalo, NY: Matthews, Northrup and Company, 1887.

Livingston, J. *That Ribbon of Highway I: Highway 99 from the Oregon Border to the State Capital*, 2nd ed. Klamath River, CA: Living Gold Press, 2005.

Masson, Marcelle and Grant Towendolly. *A Bag of Bones: The Wintu Myths of a Trinity River Indian*, 2nd ed. Happy Camp, CA: Naturegraph Publishers, 1990.

Richmond, M. *Memories of Shasta Springs: 1898–1950*. 2006.

Signor, John R. *Southern Pacific's Shasta Division—Over a Century of Railroading in the Shadow of Mount Shasta*. Berkeley and Wilton: Signature Press. 2000.

Signor, John R. and Stephen Cutting, et al. *Stations and Sidings, Dunsmuir, California*. 1999.

Tipton, Roberta. *From Siphons to Pop Tops (A History of Shasta Beverages from 1889 to 1973)*. June, 1973.

Resources

College of the Siskiyous: 800 College Avenue, Weed, California, 96094. (530) 938-4461.

Craigdarroch Castle Historical Museum Society: 1050 Joan Crescent, Victoria, British Columbia, V85 3L5, Canada. (250) 592-5323.

Dunsmuir Chamber of Commerce: 5915 Dunsmuir Avenue, Suite 100, Dunsmuir, California, 96025. (530) 235-2177.

Mt. Shasta Area Newspapers: PO Box 127, Mount Shasta, California, 96067. (530) 926-5214.

Shasta Division Archives: PO Box 412, Dunsmuir, California, 96025. (530) 235-0433.

Siskiyou County Historical Society, publishers of the *Siskiyou Pioneers* (and yearbooks): 910 South Main Sreet, Yreka, California, 96097. (530) 842-3836.

Siskiyou County Museum: 910 South Main Street, Yreka, California, 96097; (530) 842-3836.

DISCOVER THOUSANDS OF LOCAL HISTORY BOOKS FEATURING MILLIONS OF VINTAGE IMAGES

Arcadia Publishing, the leading local history publisher in the United States, is committed to making history accessible and meaningful through publishing books that celebrate and preserve the heritage of America's people and places.

Find more books like this at
www.arcadiapublishing.com

Search for your hometown history, your old stomping grounds, and even your favorite sports team.